Succeed in

Portrait Photography

David Wilson

RotoVision

Published and distributed by RotoVision SA
Route Suisse 9
CH-1295 Mies
Switzerland

A RotoVision Book
RotoVision SA
Sales & Editorial Office
Sheridan House
112/116A Western Road
Hove
BN3 1DD
UK

Tel: +44 (0)1273 72 72 68
Fax: +44 (0)1273 72 72 69
Email: sales@rotovision.com
Web: www.rotovision.com

10 9 8 7 6 5 4 3 2 1

ISBN 2-88046-811-6

Design by **Balley Design Associates**
Art direction by **Luke Herriott**
Editor **Mandy Greenfield**
Cover photograph courtesy of **Sara Richardson**

Reprographics in Singapore by ProVision Pte. Ltd
Tel: +65 6334 7720
Fax: +65 6334 7721

Printing and binding in Singapore by ProVision Pte. Ltd

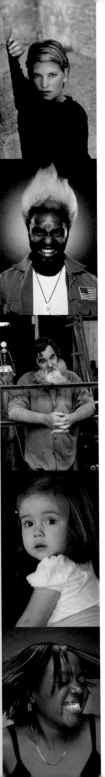

Contents

Introduction

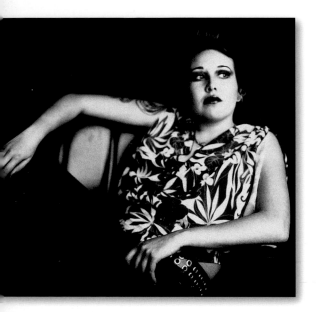

above ➤ **Sara Richardson used a black background for this image, and lit the shot with studio flash and an umbrella reflector. Hasselblad 503CM, 80mm lens, Fujicolor NPS 160 color negative film, Profoto studio flash.**

∙∙

right ➤ **Michael R. Williams takes portraits for some of the world's top music magazines. This shot of Mark Gardner, ex-guitarist with indie rockers Ride, was for an interview feature. Bronica ETR-Si, 80mm lens, Kodak Tri-X.**

Portraiture is one of the oldest branches of photography, with a long and distinguished history. Since the days of Victorian pioneers such as Julia Margaret Cameron, portraits have been an integral part of our visual history, and many individual images have achieved iconic status. Think of figures such as Winston Churchill, Marilyn Monroe, Albert Einstein, or the Beatles and it is often a particular portrait photograph that first comes to mind, fixing those people forever in their historical context.

On a more domestic level, taking pictures of people is the most common route into photography for the amateur. Think of the first photographs you ever took: the chances are that portraits of family and friends figured among them. Vacations, school trips, weddings and birthday parties, celebrations and festivals— all provide plenty of material for even the raw beginner and fill many a family album.

Making the leap
Snapshots are good for bringing back happy memories, but the family album is also likely to contain more formal portraits, taken by professional photographers, to mark specific milestones in the lives of family members. As you develop your skills as an aspiring amateur, you will want to emulate the techniques used by these professionals, taking your photography to a higher level. Equally, you might find inspiration in the work of master portrait photographers such as Karsh of Ottowa, Richard Avedon, or David Bailey, or in the cutting-edge editorial and advertising images that fill billboards and the pages of magazines.

When you begin to look at the subject with a commercial eye, a dizzying range of possibilities opens up. There are almost as many different types of portraiture as there are people. Studio work comes in many flavors, with an almost infinite range of clients and styles. Family events such as weddings, christenings, communions, and bar mitzvahs are the lifeblood of many a commercial practice, while others thrive on school portraits and graduation photos. Then there are sports teams and business executives, eager to be immortalized in newspapers or corporate brochures; and aspiring models and actors, hungry for publicity pictures for their portfolios. Location work is just as varied, running from gritty photojournalism to fine-art images destined for use as prints or posters.

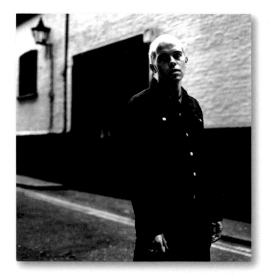

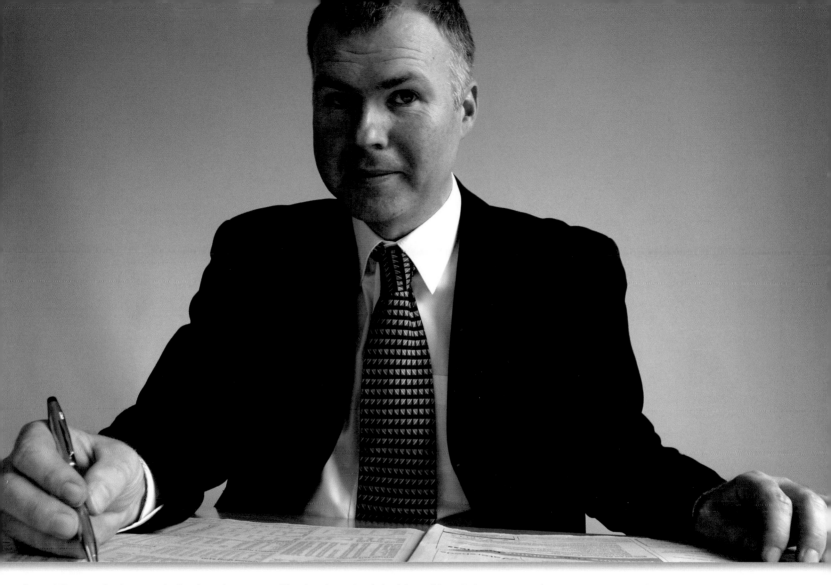

Potentially, portrait photography is a lucrative business. As you hone your skills as a budding pro, you are likely to pick up the occasional commission. It's a natural step from here to wonder how you can break into the business and even make a full-time living from it. There are plenty of photography courses for aspiring pros that claim to offer instant riches and a jetset lifestyle—but take their claims with a pinch of salt. It requires a lot of hard work and dedication even to begin to make money from photography, along with a level-headed and coolly professional approach.

above ➤ Businesses of all sorts regularly require images for press and public relations use. Bi Scott used available window light to illuminate her subjects when she was commissioned to shoot the directors of a consultancy company. Canon EOS 300D, 18–55mm lens, set at ISO 200.

2A 3 ➡ 3A

Have you got what it takes?

Be realistic when you ask yourself what you want to achieve. Do you simply want to improve your technique and expand your repertoire, so that portraits of family and friends have something a little extra? This can be worthwhile and satisfying in itself, even if it remains at the level of a hobby.

Perhaps your work is good enough to attract the occasional commission. In the beginning, this is most likely to come from people you already know. You should establish your method of working right from the start. Are you going to charge for pictures, even if your clients are friends or family members; and if so, how much? If you are asked to photograph a wedding, do you think you could handle the responsibility? Remember, a wedding is the bride's big day and the photographer has one chance to get it right.

If you harbor ambitions of going into portrait photography full-time, you must be thoroughly professional in your approach and treat it like a business. Your potential clients are all-important. People won't entrust you with commissions if your work appears below-par or sloppy, or if you are unhelpful or unprofessional in any way; nor are they likely to recommend you to others. You also need extremely good people skills. You have to be cheerful and enthusiastic, able to put even

right ➤ **Publicity shots for actors are one of the staples of David Fisher's studio work. This was lit with a softbox high to the left and a reflector low on the right. A second light picked out the subject's hair. Nikon F100, 85mm lens at f/1.8, Ilford Delta 400.**

the shyest of clients at their ease. This is an essential quality for a portrait photographer, and its importance cannot be overemphasized. Equally vital is a solid sense of humor.

In addition, you will need a good head for business. Your first concern is to let people know you exist, and for this you will need promotional flyers, headed stationery, business cards, and ideally a Web site. Computer literacy is an essential, as is the ability to keep clear and accurate records. Remember, as money starts to come in, you will be obliged to deal with the tax authorities, so you must be scrupulous in maintaining up-to-date accounts.

However, for the photographer with the necessary skill, determination, and dedication, plenty of rewards await. Running your own portrait business is a very satisfying way of making a living and, for many pros, the thrill of seeing their photographs hanging on a client's wall or adorning the pages of a magazine never fades. Don't expect to become a big name or command huge fees. Instead, study your markets, be realistic in setting your targets, and be prepared for a lot of hard work. That way, you too will be able to succeed in portrait photography.

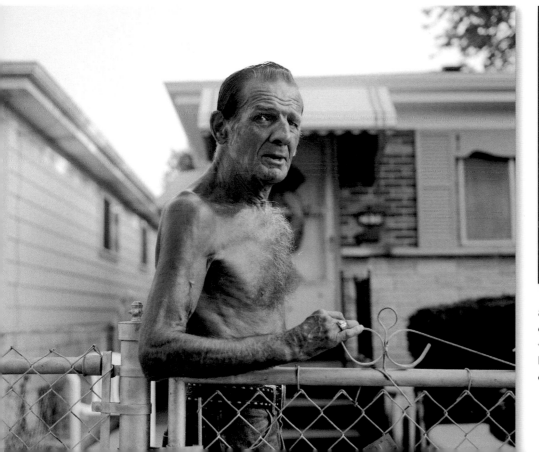

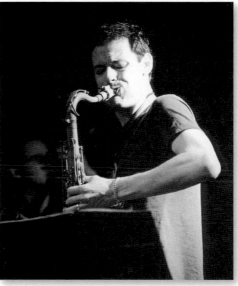

above ➤ **Paul Medley shoots live jazz—here he captured saxophonist Pete Wareham.**

left ➤ **Stefan Hester takes location portraits on the streets of St. Louis.**

RVP ▷ 11 RVP ▷ 12

Getting started

" A successful portrait involves more than simply

8A 9 ➜ 9A

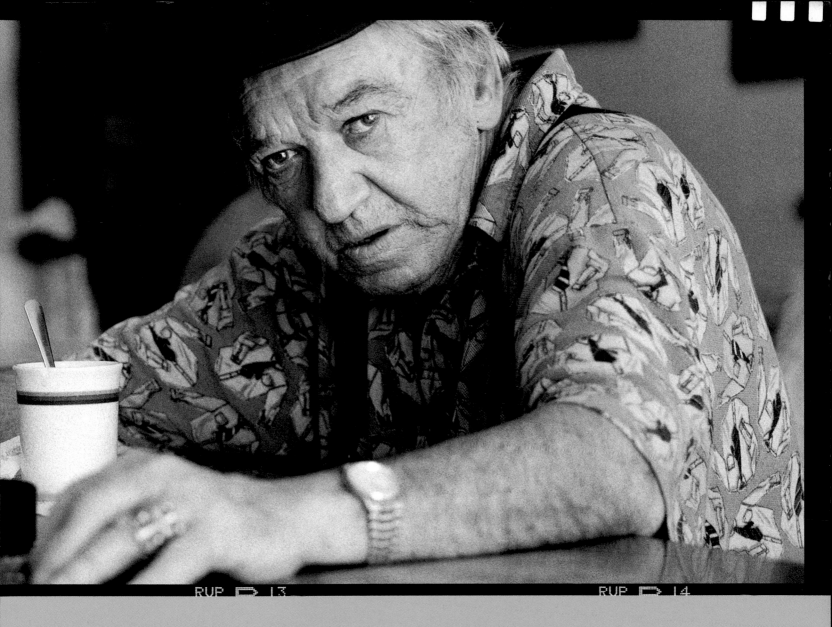

RVP ▷ 13 RVP ▷ 14

capturing a likeness—it's about communicating character and personality. **"**

Getting started

Cameras and film

Any camera—even a compact—can be used to take a portrait. Indeed, many professionals carry a compact in their kit bag, to use as a visual note-taking device or simply as backup. However, if you are approaching the subject seriously, you need at least a good-quality SLR.

In 35mm photography, the lens most widely recommended for portraiture is an 80mm. A moderate telephoto of this focal length produces a slightly flattened perspective, which is flattering to facial features. A wide-angle, on the other hand, tends to distort faces and so is rarely used,

unless the photographer is deliberately aiming for an exaggerated effect. A standard 50mm lens can also work well, especially in location portraits where the background is important. Standard lenses usually have a larger maximum aperture, giving more scope for pictures in low light. Perhaps the best choice (especially for those on a limited budget) is a medium-length zoom, say 28–105mm. This may not offer quite the image quality or the aperture range of fixed focal-length lenses, but it compensates in terms of flexibility and framing options, allowing you to deal with everything from group shots to closeups.

While 35mm is extremely adaptable, medium-format cameras offer a larger image size and therefore more detail and better quality. They are popular with portrait photographers, both in the studio and on location. They use roll film in a variety of formats, the most common being 6x6cm, 645 (6x4.5cm), and 6x7cm. Lenses tend to be fixed; 80mm is again a popular choice, though in medium format this is regarded as a standard lens, while 120mm is a moderate telephoto.

Some photographers work with large-format cameras, which are more usually employed for landscapes. They take sheet film, commonly in 5x4in and 10x8in sizes. They are more complex

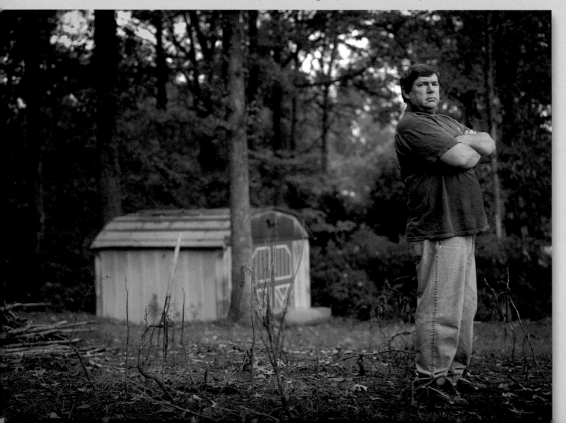

left ➤ **Whenever he can, Stefan Hester uses a large-format camera for portraits. For this study of his father Jimmy, standing in his backyard in Atlanta, he had time to think carefully about the focusing and composition of the shot. Calumet 5x4in monorail camera, 150mm lens and tripod, ¹⁄₆₀ sec at f/8.**

right ➤ **Bi Scott took advantage of the setting sun to light this portrait, which was taken on the Orkney Isles in the far north of Scotland. She used print film to record the vibrant colors. Canon EOS 5, 28–105mm lens, Fujicolor 200.**

to operate, having a bellows and a number of lens movements (tilt, shift, and front rise and fall) that can fine-tune the image, but offer superb quality. The two main types are flatbed (or field) cameras, which fold up into a box; and monorail (or view) cameras, which are lighter and easier to adjust.

Selecting the right film

Film choice is largely a matter of personal preference. Prints can be obtained from both color negative and color transparency (chrome) films. The latter generally give better color saturation and finer detail, but exposures have to be absolutely spot-on. Color negative films give perfectly good results in most situations, and are more forgiving of minor exposure errors. In some situations, black and white is a more attractive option, and again there is a wide choice of emulsions.

A film's sensitivity to light is measured in terms of speed, which is expressed by an ISO (International Standards Organization) number. Films with a high ISO number can be used in low lighting conditions, but the higher the speed, the more apparent the grain. Film speed can be uprated or downrated during exposure, to increase contrast or to compensate for low light. Popular brands of film come in different sizes, meaning that the same film stock can be used with 35mm, medium-format, or large-format cameras.

The digital option

Digital cameras have made huge advances in recent years and now outsell film cameras, at least in the compact and SLR segments of the market. As with any electronic product, costs have fallen as the technology has matured, and the price gap between digital SLRs and their film counterparts has narrowed. At the same time, image quality has improved dramatically and now routinely rivals that of 35mm.

Digital images are captured and stored in a variety of file formats (RAW, JPEG, TIFF) and on a range of storage media (including memory cards, CDs, and hard drives). To store, view, and manipulate them you need a PC or a Mac, together with image-manipulation software, and a good-quality printer for output. All of this represents a sizable investment over and above the cost of the camera equipment itself. The maximum print size obtainable depends on the amount of data recorded on the camera's

far right ➤ **David Fisher shot this publicity picture on a digital camera and cleaned it up afterward in Photoshop, airbrushing out stray pieces of confetti. Nikon D100, 28–70mm lens.**

below ➤ **Bi Scott used color print film for this portrait of estate worker Dave Coles with Archimedes, the longhorn bull. Canon EOS 5, 28–105mm lens, Kodak Gold 200.**

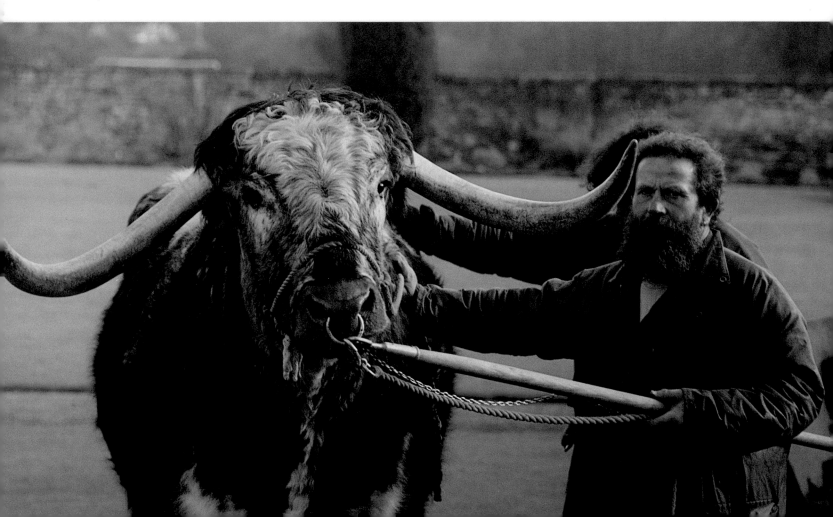

Digital pros and cons

Pros

1 Images can be viewed instantly on the camera's LCD (liquid crystal display) screen and, if not up to scratch, discarded and reshot. They can also be printed instantly, e-mailed, or uploaded to the Web.

2 With no need for film or processing, running costs are low.

3 Images can be modified or manipulated onscreen, to retouch blemishes, eliminate red-eye, or introduce creative effects.

4 The user can switch between color and black and white, and alter film speed, at the touch of a button, eliminating the need to change films or carry spare camera bodies or backs.

5 Technical data—such as white balance and exposure details—are recorded with every frame, which makes record-keeping easy.

Cons

1 The camera's built-in screen drains power, meaning batteries must be changed frequently.

2 Keeping cameras clean is even more critical than it is with film. If you get a speck of dust on the chip, you'll probably have to send the camera away for professional cleaning.

3 Startup costs are high, because you need to buy a computer, printer, and software in addition to camera and lenses.

4 Downloading files to a PC and manipulating them onscreen can be fiddly and time-consuming. If files are not meticulously archived and labeled, they can be difficult to retrieve.

5 The technology is still evolving. Software and equipment quickly become obsolete, and it is hard to predict how compatible current storage media will be with future systems.

chip, which is expressed in megapixels. Many entry-level digital SLRs now offer resolutions of 2–3 megapixels, while professional models boast 12 megapixels and above. Digital backs are available for medium- and large-format cameras, and these give impressive results. However, they are very expensive and are intended for high-end professional use.

Existing 35mm users will be glad to know that most camera manufacturers have designed their digital SLR ranges to be compatible with conventional lenses, meaning there is no need for the digital convert to junk his or her entire equipment bag and start from scratch.

But although some digital cameras have "full-size" sensors, in most systems the image chip—and therefore the picture area—is smaller than a standard 35mm film frame. This means that the nominal magnification of the lens is greater: roughly 1.5x that of 35mm, which effectively turns a 50mm lens into a 75mm. A typical zoom designed specifically for a digital camera is 18–55mm.

Engaging with the subject

Taking a successful portrait involves a lot more than simply capturing a person's likeness. Your goal should be to communicate something of their character and personality too. To do this, you need to engage with them on a personal level.

The amount of time a photographer spends with each subject varies widely, according to the nature of the shoot. If you are taking pictures of

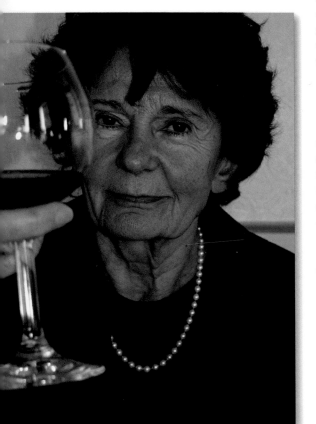

a friend for your portfolio, you may have all afternoon. If you are a press photographer covering an appearance by a public figure, you might have five minutes. Commercial studio sessions can be as long as a couple of hours or as brief as 15 minutes. Whatever the length of the session—and however formal or informal— the photographer should constantly be trying to connect with the subject. This requires a friendly face and good communication skills. It helps enormously if you have the ability to keep a conversation going, whether it's about the subject's life and interests or simply about the weather. People will be more relaxed if they feel they are part of a collaborative process.

right ➤ Stefan Hester was experimenting with a home-made lighting rig when his subject knocked on the door. Hester placed the strip lights in front of him, one angled to either side, in effect boxing him in; the catchlights can be seen in his eyes. Calumet 5x4in monorail camera, 150mm lens, Polaroid Type 55 Positive Negative film, ⅟₃₀ sec at f/5.6.

...

left ➤ This portrait by Bi Scott shows her mother on the day of her father's funeral, raising a glass of wine to him after 50 years of marriage. "I was aware of intruding with the camera on a private, possibly taboo, event, but dared to shoot because I was an insider," says Scott. Canon EOS 300D with 18–55mm lens, set at ISO 400, ⅟₃₀ sec at f/5.6.

Establishing a rapport

"It's important that the subject is allowed to feel comfortable about being themselves," says David Fisher. "The personal rapport is what makes them feel relaxed and less self-conscious in front of the camera." In the studio, Fisher spends a lot of time trying to put his clients at ease. He works without an assistant, because another person in the room would alter the relationship between him and the subject. When he asks clients to pose for the camera, he works hard to get their body language right, directing the way they turn their shoulder or place their hands.

For the documentary photographer, on the other hand, a subject who is not expecting to be photographed can often be the most interesting. When a carpenter working on a neighbor's house knocked on his door, asking if he could use the telephone, Stefan Hester made a trade: a photograph for a phone call. He shot two sheets of film and the session was over. "It's a very pure image of that person—a staged, well-lit portrait in a studio setting, but with no pretext on the part of the subject for being there. As a photographer, you have to be prepared to take a picture at almost any moment. In this case, the opportunity literally walked into my house."

Hester has got into the habit of shooting a Polaroid instant picture at the start of a session. "It's not just the obvious reason of testing the exposure—it also helps me to build my own confidence. Just as important, it allows me to give the subject a gift of the experience on the spot."

"It's important the subject is allowed to feel comfortable."

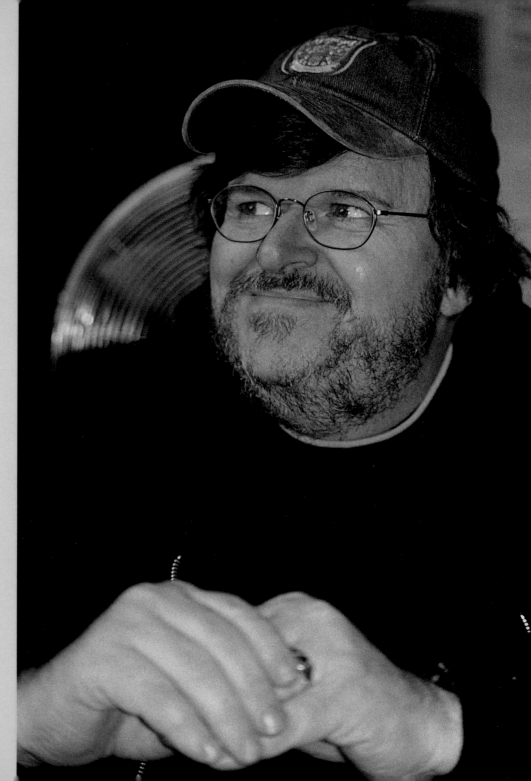

Take your time

Some people are naturals in front of a camera, but many feel awkward and self-conscious, which results in strained expressions and wooden postures. You can't force a person to smile naturally, but you can help them to relax by chatting with them—perhaps asking them about their families, jobs, and hobbies, or where they plan to spend their next vacation. Once you've established some kind of rapport, they are more likely to unwind and be themselves—and this, of course, is what you are trying to capture.

Hands are a particular difficulty: most people just don't know what to do with them. Suggest different solutions: hands clasped loosely together in a relaxed pose, or cupping the face to act as a framing device. Giving the subject something to lean on, such as the back of a chair, often works well, as does providing a simple prop to hold, such as a glass, pen, or hat. Most studio photographers keep a small supply of colorful props at the ready to engage the attention of young children.

right ➤ **Jim Gordon shot writer and filmmaker Michael Moore at a screening of one of his films. Light levels in the cinema bar were low, so Gordon asked his subject to sit by the window while he used a burst of bounced flash to supplement the lighting. Nikon F50, 70–210mm lens, Kodak Tri-X 400, ⅟₃₀ sec at f/5.6.**

It benefits you as a photographer if you can slow down and relax, and one of the best ways of doing this is by using a tripod. The most obvious advantage of a tripod is that it holds the camera steady and reduces the risk of camera shake. It also encourages you to think more deliberately about the composition of the picture. However, just as usefully, shooting with a tripod and a cable release allows you to stand away from the camera. You can continue to communicate naturally with the subject, chatting and maintaining eye contact, and fire the shutter when the moment seems right. This way, there are no awkward pauses as you disappear behind the camera—in fact, the subject may barely be aware that the picture is being taken.

The same is true of large-format cameras. Using a camera of this type is a very slow and deliberate process, and requires a lot of cooperation from the subject. You have to view the image upside-down, and go through various steps—cocking the shutter, inserting the dark slide, and so on—before you're ready to shoot. When the camera is set up, you can't look through the viewfinder, but the advantage of this is that you can study the subject and his or her relationship with the camera at your leisure. In addition, you don't have that momentary blackout when the shutter fires, so you have a better idea of whether the shot has worked, or whether the subject blinked at just the wrong moment.

If you find yourself shooting a well-known person—a musician, actor, or sports star, for instance—you should not expect to establish an immediate rapport. Most celebrities are used to being in the public eye and have developed coping mechanisms that may disguise their true feelings. "I aim to get a suggestion of the

individual, but more often than not you find yourself making an image of which the person is just a part," says Michael R. Williams, who photographs big-name rock musicians for a living. "Famous people have a public face. You might get a look or a glance that hints at something more, but it's rare. At the minimum, what you want is something that works photographically."

above ▸ **When Gordon shot publicity pictures for comedian Mark Thomas at the offices of a TV company, he found the light indoors unsatisfactory, so they moved outside. A zoom helped him crop in tight on his subject. Nikon F50, 28–200mm lens, Ilford XP2, 1/1000 sec at f/5.6.**

above left ▸ **Suitable locations were limited at the venue where author Hanif Kureishi was giving a book reading, but Gordon found a window bay that framed his subject nicely. Kureishi went to move the beer glass out of shot, but Gordon insisted he keep it in, and this helped to break the ice between the two of them. Nikon F90X, 17–35mm lens, Kodak Tri-X 400, 1/60 sec at f/1.5 with bounced flash.**

The eyes have it

Occasionally you may want to portray a subject gazing away into the distance or sunk deep in thought, in which case it's perfectly acceptable to have him or her looking away from the camera. Most of the time, however, eye contact is essential if a portrait is to succeed. Eyes are, after all, the key to the subject's personality, and good eye contact conveys his or her mood far more effectively than any smile.

It's essential that the eyes are in sharp focus, even if other parts of the frame are not. When composing your shots, get into the habit of focusing on the eyes first, zooming in on the subject's face if necessary. You can then reframe the shot the way you want it, holding focus while you do so.

At the same time, you want your pictures to give the impression that the subject is connecting directly with the viewer, rather than with a camera. This is where a tripod and cable release

are useful, because they allow you to step away from your equipment and maintain eye contact with the subject while you shoot. This can be especially important with children, who are apt to put on a cheesy grin when confronted with a camera. You can vary the directness of the contact by moving closer to the camera position or further away, while encouraging the subject to follow you with his or her eyes. Be careful of moving too far away, or your subject will appear to be gazing out of the side of the frame.

The size of the eyes in the frame will, of course, depend on the composition, and to some extent on the subjects themselves. The eyes of children and babies are much larger in proportion to their faces than those of adults. Babies' eyes, in particular, can appear huge—an appealing characteristic on which the portrait photographer can capitalize. However, involuntary blinks and eyes screwed shut spoil a portrait, and these frames should be discarded when presenting a client with the final selection from any session.

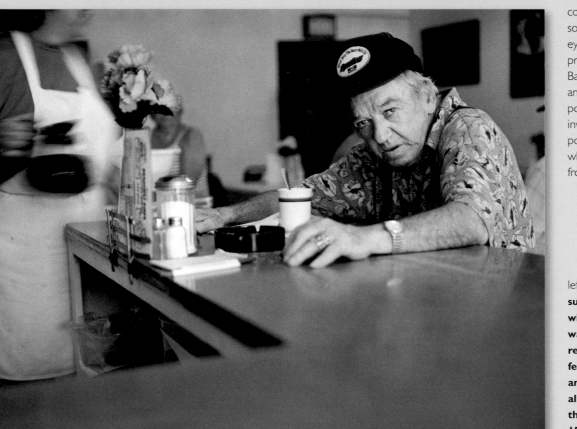

left ➤ Stefan Hester was out looking for subjects to photograph when he got talking with this man in a diner in St. Louis. He was a war veteran who did odd jobs there and had a regular seat at the counter. Hester quickly fetched his camera and tripod from his car and ran off two rolls of medium-format film, all the time keeping up a conversation with the man and the other customers. Mamiya RB, 150mm lens and tripod, ⅛ sec at f/5.6.

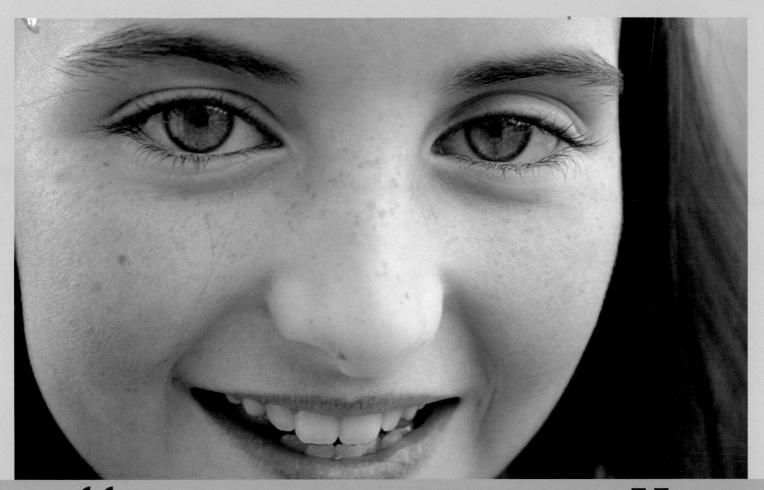

> **Eye contact is essential if a portrait is to succeed.**

Both the pictures shown here demonstrate direct eye contact with the camera, though the shots were framed in very different ways. In Bi Scott's picture of the bridesmaid, the subject is caught in large closeup and her eyes are prominent in the frame. In Stefan Hester's shot of the man in the diner, the subject is relatively small in the frame, but his face is placed roughly on an intersection of thirds, drawing the viewer's attention toward his eyes. The framing device of the counter in the foreground also helps to channel attention in that direction.

above ➤ **Bi Scott was struck by the green eyes of this young girl, a bridesmaid at a wedding, and framed her shot as a big closeup, concentrating attention on the face. Canon EOS 300D, 18–55mm lens, set at ISO 200.**

25A 26 ➡ 26A

Framing the shot

There are many different ways to frame the human figure: portrait photography goes far beyond the classic head-and-shoulders shot or the mugshot on a passport or driving license. You should consider the scene in front of you—person included—as your raw material. Every frame you take is selective, in that it involves cropping part of the general view to fit the parameters of your camera's viewfinder. You may choose to include large areas of the background to give context to the subject, or you may want to crop in boldly on a face to isolate it from its environment. Your skill as a photographer lies in selecting the portion of the scene that will make the most effective photograph.

The "rule of thirds"

An often-quoted compositional device is the rule of thirds, which is a close equivalent of the "golden mean" used in classical painting and architecture. Imagine a grid placed over the viewfinder frame, with two lines splitting it into three equal portions horizontally, and another

two lines splitting it into three equal portions vertically. Placing elements of the composition on or near the points where these lines intersect helps to concentrate attention on them, while at the same time creating a sense of balance within the frame. In a portrait photograph, it is very effective to place a person's head on an intersection of thirds, or in a closeup, one or both of their eyes on an intersection.

There's no need to feel bound by this rule, however. Sometimes an image has greater impact if the subject is placed centrally in the frame, or to one side. There's also nothing to stop you having two different points of focus within the frame. This introduces a degree of tension into the composition, encouraging the viewer to scan back and forth from one point of interest to the other.

left, above, right, and far right ➤ **Initially Bi Scott thought this couple might take offense at being asked for a photograph, but once she'd dared to take the first shot, she seized the opportunity to use up her remaining half-dozen frames to shoot as many variations as she could. Her medium-range zoom allowed her to adjust the framing quickly, moving from a full-body upright shot of the pair to a tighter horizontal crop, and then individual head shots. Canon EOS 5, 28–105mm lens, Fujichrome Sensia.**

Unless you are working to a strict brief, try out a variety of different framing options for each of your subjects. Some shots work better vertically (portrait format), while others are more effective when framed horizontally (landscape format). Compositions can vary from full-length body shots to tight closeups that show just the face. Get into the habit of running through the options systematically. A quick and effective way to do this is to use a zoom lens with a moderately wide range—say, 28–105mm in 35mm format, or 18–55mm for digital. A zoom allows you to adjust your composition quickly without having to change camera position, and can be particularly useful if you have only a few moments to get the image you are looking for.

Compositional devices

A tripod is perhaps the best aid to composition you can have. Using one makes you think more carefully about framing the shot than is generally the case when shooting handheld. It also allows you to use slower shutter speeds—to cope with low lighting conditions—and smaller apertures, to introduce greater depth of field into the picture. Depth of field is an important compositional device in its own right: there is a big difference between a portrait taken with a small aperture, so that details are sharp from front to back, and one taken with a large aperture, in which the subject remains in sharp focus, but the background details blur into insignificance.

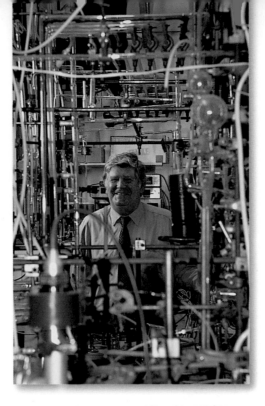

Another important element is color. Compositions work better when colors are harmonious. Bright colors distract attention from the subject, even if they are in the background. Consider, for example, the effect of a bystander in a bright red jacket caught in the background of a portrait shot. Always check the frame before shooting to ensure that such distractions are excluded.

There are plenty of creative alternatives to the "head-on" shot. Wherever possible, explore different angles of view, perhaps lying down on the ground so that you are looking up at the subject, or searching out a high angle so that you are looking down: for instance, from an upper-story window or a rooftop. Many professionals—especially editorial and fashion photographers—carry a portable stepladder for just this reason.

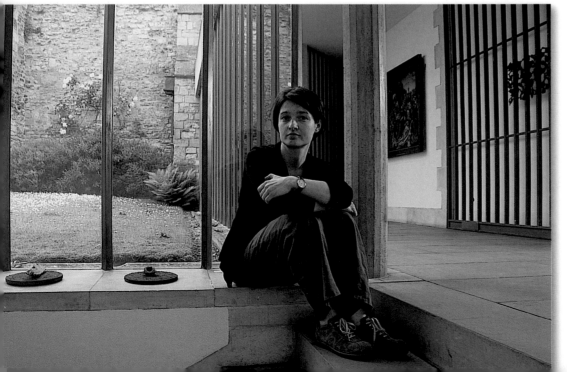

above left ➤ The glass tubes in scientist Richard Wayne's laboratory created an ideal "frame within the frame." Bi Scott was short of space, but managed to squeeze in two studio lights, one aimed down the center of the tubes, the other parallel and to the side, with a reflector at the level of the subject to bounce light back onto his face. Canon EOS 5, 28–105mm lens, Fujichrome Sensia.

left ➤ Scott wanted to capture Jacqueline Thalmann, assistant curator at the college picture gallery, in a relaxed pose, but was keen to incorporate the verticals of the building. "I always find it a challenge to pose subjects in front of windows, because of the need to balance natural backlighting with studio lights and avoid reflections on the glass." Canon EOS 5, 28–105mm lens, Fujichrome Sensia.

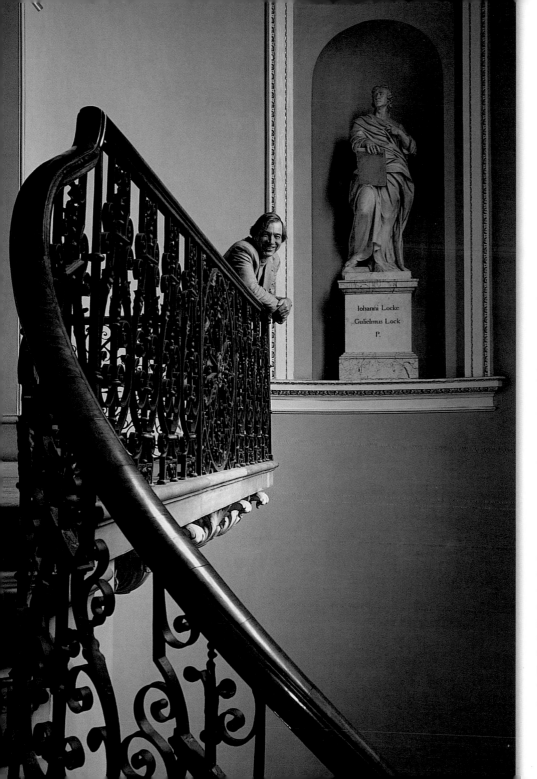

"Frames within the frame"

Many locations have features, either manmade or natural, that can be used effectively as a setting or a frame within the frame. Doors, windows, and archways all work well in this context, as do tree branches, foliage, and rock formations. Other features—such as staircases and corridors indoors, or fences and hedges outside—can be used to lead the eye into the frame, drawing attention toward the subject.

Bi Scott began her project at Christ Church College, Oxford, UK, when she was asked to photograph a half-dozen academic staff for a fundraising brochure. She decided to extend the project to include all the staff (academic and nonacademic) in their workplaces around the college. Its venerable buildings and beautiful grounds gave her plenty of choice when it came to locations, and in many cases architectural details suggested themselves as compositional elements to help her frame her shots. She was keen to get as much detail as she could into her pictures, so in most cases she opted for a small aperture to create the maximum depth of field.

left ➤ **The architectural sweep of the banister on the library staircase provided Scott with a dramatic compositional device for her shot of philosopher Hugh Rice. In the background she included a statue of his 17th-century predecessor John Locke, an alumnus of Christ Church College. Natural lighting from a window provided the illumination, but Scott had to struggle to balance her tripod on the steps. Canon EOS 5, 28–105mm lens, Fujichrome Sensia.**

getting started [23]

Be bold

There's no rule that states you have to include the whole of a person in a portrait—or even the whole of their face. In certain instances you may choose not to portray the face at all, focusing instead—in the case of a bride wearing a new wedding ring, for example, or a musician playing at a keyboard—on the subject's hands. Bold crops can add interest and impact to the image. Tackle each subject on its own merits, and don't be afraid to push the boundaries.

When composing closeups, you can either get in close physically with your camera, or use a long lens or a zoom to isolate a section of the subject. Cropping can also be carried out at the post-production stage, either digitally or in the darkroom. You may spot an interesting crop that didn't occur to you at the time of shooting, or want to tighten the composition up a little. Purists would doubtless argue that it's best

right ➤ **For this shot of his niece Jessica, Jim Gordon cropped in close with a zoom lens. He placed her against a plain wall and lit the shot with flash bounced from the ceiling. Nikon F50, 28–200mm lens, Ilford XP2, $^1/_{300}$ sec at f/11.**

far right ➤ **Paul Medley lit this publicity shot of harpsichordist Arne Richards with a tungsten photoflood placed to the side. Olympus OM1, 35mm lens.**

center right ➤ **Here Medley cropped in tight on the keyboard, composing the shot so there would be space to superimpose text. Bronica ETR-Si, 80mm lens and tripod, shutter speed $^1/_8$ sec.**

" Tackle each subject on its own merits. **"**

to compose in-camera. Perhaps more to the point is the fact that the greater a section of an image is enlarged, the more apparent the film grain or pixels become. For this reason be wary of enlarging very small portions of the frame.

Sometimes a bold crop is dictated by the intended use of the image. Editorial and advertising photographers always shoot their pictures with a mind to how they will look on the page. In some cases they will take a wide view, using a neutral background and leaving plenty of space around the subject, so that a designer can insert a headline and text at a later stage. In other cases, they may zoom right in so that the picture itself can be used as the background. For this type of shot, it's important to leave parts of the frame relatively uncluttered, so that text can be inserted over the image without obliterating the main point of interest.

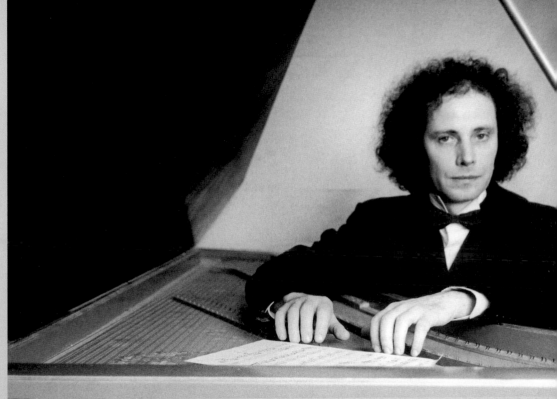

Case study: **Stefanie Herzer**

Originally from Hamm in northern Germany, Stefanie Herzer now lives and works in San Francisco, California. Her background was in software engineering: she studied computer science and worked in that industry for 20 years. Now she's a full-time professional photographer —24/7, in fact. As she points out, you have to invest a lot of time and effort to make a success of things, especially at the beginning.

Herzer has only taken up photography seriously over the past few years. "I had a good eye for framing, and I used to make 8mm movies to enter for competition, which gave me some foundation," she explains. "I had a 35mm camera, but like any amateur I would shoot only in my spare time, perhaps a roll of film a month. Mainly I took landscapes—I knew nothing about portraits."

This changed in 2001, when Herzer bought her first digital SLR. Originally she used it for landscapes, but because she wanted to work with people she turned to portraits, and she's never looked back. "I'm totally digital now," says Herzer. "With digital you can develop your skills much faster because you have instant feedback."

Turning professional is not a step to be taken lightly. An amateur may have an excellent eye, but, according to Herzer, when you're a pro you have to be able to manipulate any situation to get perfect results every time, whatever the lighting conditions. "Rules for portraits are different than for other types of photography," says Herzer. "There are no second chances: you have to make sure the light on the face is right. You always want to flatter your subject, make them appear slim and as symmetrical as possible."

" Rules for portraits are different than

"My pictures aren't quite as colorful as those of some US photographers. I think my style is slightly more muted, and European. I still love landscapes, but it's also a lot of fun working with people. They get very excited about the results, and that's what's so rewarding. If you create a really nice wedding album, the client will treasure it for years to come."

far left ➤ **Stephanie Herzer photographed this boy in a local park. Canon EOS 1DS with 70–200mm IS lens, set at ISO 100, ½₀₀ sec at f2.8.**

left ➤ **Here Herzer used a symmetrical studio lighting setup to achieve an attractive result. Canon EOS 1DS, 70–200mm lens.**

below ➤ **This shot of baby Gianna was taken with two off-camera flash heads fired into umbrellas. Canon EOS 1DS with 24–70mm lens, set at ISO 100, ⅙₀ sec at f/7.1.**

To achieve more interesting results, it's vital to find out as much as you can about the subject. Herzer talks at length to her clients, and allows them to have their own creative input. "I spend at least an hour talking," says Herzer. "For example, I ask people what they do, where they go to have fun. For an engagement picture I ask the couple where they met originally, where they proposed. Of course, all this takes up time, so you have to build it into your pricing structure. It's worth it for the client, as the results are so much better."

Herzer's style has been constantly evolving from year to year, and indeed from session to session. In future, she believes, she will move toward a more environmental style of portraiture. It's important to keep learning your craft, and she advises studying the work of photographers and painters you admire. "You can always learn from the really advanced people. Don't just focus on the technical aspects—you should analyze why you like the results and try to incorporate what you learn into your own work," she says.

for other types of photography. 〞

Using backgrounds

Backgrounds can make or break a portrait, and different backgrounds radically alter the mood of an image. Your locations need not be exotic. The place that a person lives in says a lot about their personality, and they are likely to be more relaxed there than in a strange environment. If you're shooting at the subject's home, look for the places where they spend the most time. If they're a keen cook, for example, ask them to pose in the kitchen. The same is true of someone's workplace. Although these are usually less individual, you can still convey a lot about the subject's character, especially if you include a few personal items as props.

If you're stuck for a background, it's possible to treat any location as a studio and simply create your own. A simple painted wall acts as a blank canvas against which the subject can be posed. With a little preparation, you can set up a roll of colored studio paper, or paint a sheet of board or paper to suit your own taste. A completely different feel is created using fabrics, such as silk, muslin, or velvet. These can be pinned up against a wall behind the subject, or simply draped over a door or piece of furniture. If you're shooting in color, however, you should have an eye to what the subject is wearing, and avoid excessively vibrant background colors that clash with their clothing.

Less is more

While adding interest, it's important that backgrounds should not be too "busy." You should try to keep things relatively simple, avoiding clutter and excluding objects that may be too eye-catching and draw attention away from the subject. A simple way to do this is to focus in close on the subject and use the widest possible aperture that your lens will allow. This way, the subject remains sharp, while the background blurs out of focus. The effect is accentuated if you use a telephoto lens. Another approach is to shoot in black and white, which reduces background colors to shades of gray.

Public spaces can provide interesting backdrops for editorial-style portraits, such as portfolio pictures for aspiring actors or models. Shopping malls, bars, restaurants, and hotel lobbies all offer distinctive environments, with plenty of scope for creative framing. Be aware, however, that many locations of this sort impose legal restrictions on people taking photographs, especially if the images are intended for commercial use. Check out beforehand with the management whether you are likely to need permission.

left ➤ **Bi Scott shot academic Christopher Butler in the library of Christ College, Oxford, UK. The ancient volumes on the shelves behind him provided a neutral background, while the soft side-lighting slanting through a window picked out the statue, which provided a compositional counterbalance. She had to meter carefully and bracket her shots to be sure of getting an acceptable exposure. Canon EOS 5, 28–105mm lens, Fujichrome Sensia.**

below ➤ **Wedding receptions are often held in grand locations, such as hotels and country houses, and these provide plenty of interesting backdrops. Scott always looks for a "monumental" shot, if possible using an archway, either natural (such as tree branches) or manmade. Canon EOS 5, 28–105mm lens, Kodak Gold 200.**

Out in the open

Backgrounds are just as important outdoors. Unless the location is very particular to the subject you are photographing, outdoor backgrounds are less likely to convey essential information about their personality. Instead, you should look for backdrops that work visually, in a simple but pleasing way.

At the same time, you should pick a background that broadly mirrors the character of the person you are photographing and the mood you are trying to convey. An elderly person, for instance, may best be portrayed against a garden fence or a clump of foliage, while a young person with attitude would probably fit better in an edgy urban environment, leaning against a brick wall covered in graffiti or posed against the architectural patterns of a modern building.

Whatever the background, make sure it doesn't overwhelm the subject. Avoid clutter, and beware elementary mistakes such as telephone poles or aerials sprouting from the subject's head. Scan the viewfinder carefully for such intrusions when composing the shot, and use a wide aperture if you can, to soften the sharpness of the background.

Isolating and lifting a subject

Sometimes the sky itself makes a splendid backdrop. Stefan Hester took his portrait of artist John Lutz on a rooftop in Astoria, New York, with the subject posed against a bank of clouds. He injected a sense of drama into the shot by using two flash heads with reflectors: this had the effect of overpowering the sunlight and isolating the subject against the background. "When you're exposing for the subject in this

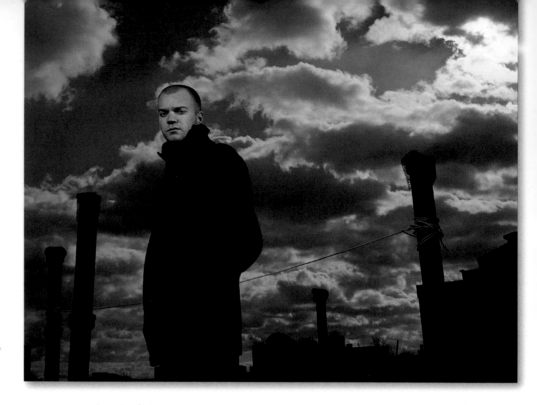

way, you can adjust the flash as much as you want, and bring down the value of everything else in the frame. If I'd been exposing for the background, I would have needed at least two stops more, and I wouldn't have got anywhere near as much detail in the clouds."

For the shot of the boy squatting in the road, Hester used the low, directional late afternoon sunlight to backlight the subject and lift him out of his surroundings. You don't need ultra-sophisticated exposure systems to be creative in this way. Hester used an old Speed Graphic rangefinder camera, of the type once favored by press photographers. These can be picked up quite cheaply secondhand. "They're easy to frame with, and the aperture and shutter speed settings are all in the lens," he says. Incidentally, as Hester points out, it's not a smart idea to go around shooting pictures of children

in the street without the permission of their parents. Here, the boy's father was working on a car just out of shot and gave the photographer the go-ahead.

above ➤ **Stefan Hester used two flash heads with reflectors to pick out the subject. Calumet 5x4in monorail camera, 150mm lens, Fujichrome Provia 100F, ¹⁄₂₅₀ sec at f/11.**

right ➤ **"You have to work with what you've got," says Hester. "Here I wanted to make use of the light in the background, and also tried to include something of the St. Louis neighborhood." Speed Graphic 5x4in camera, 150mm lens, handheld, Fujichrome Provia 100F.**

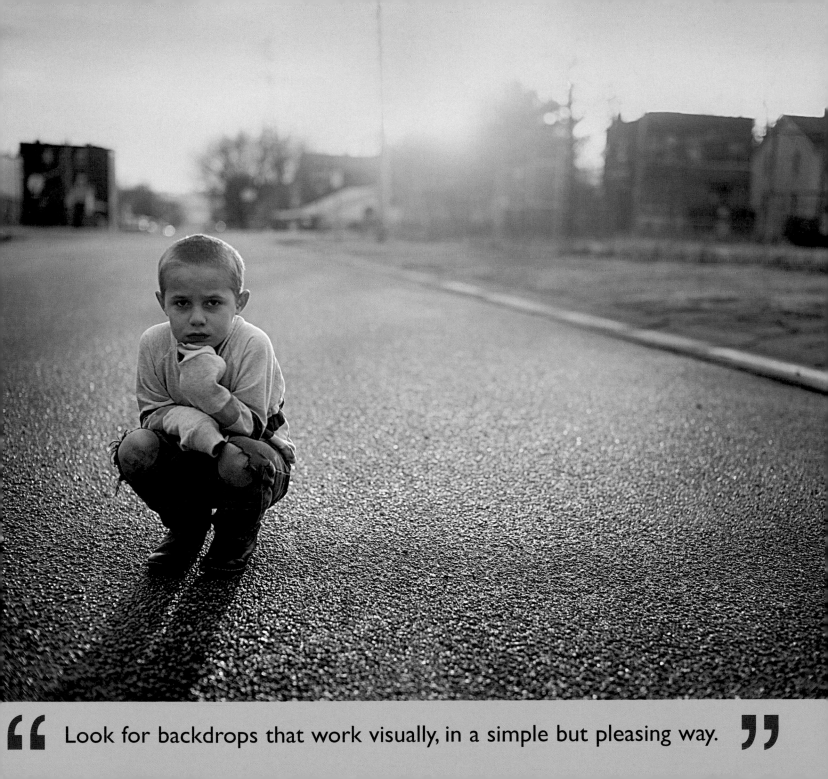

" Look for backdrops that work visually, in a simple but pleasing way. "

Lighting

" The range of possible lighting situations runs

RVP 13 RVP 14

from clear blue skies to a candle in a darkened room. "

Lighting

Shooting outdoors

The nature of light varies enormously, depending on its source. Our eyes and brain tend to compensate for different types of light without our being aware of it, but a camera is not as intelligent—it simply records things the way it "sees" them. This means that lighting conditions captured on film are often exaggerated compared with the way we remember them.

The range of lighting situations that the portrait photographer is likely to encounter runs from clear blue skies at one end of the scale to a candle in a darkened room at the other. Light sources are classified in terms of color temperature, which is measured in degrees Kelvin (K). The higher the Kelvin figure, the bluer the light. Natural daylight is usually at the blue end of the spectrum. Electronic flash light is designed to mimic this, but other artificial light sources, such as

left ➤ **Sara Richardson used natural daylight for her promotional shots of artist and musician Teddy Days, taken at various locations around Los Angeles. It was a bright, sunny day, but she found an area of shade where the light was softer. In terms of color temperature, shadow areas tend to be strong in blue tones. Hasselblad 503CM, 80mm lens, Fuji Provia 100 transparency film rated at ISO 80.**

..

above ➤ **For this moody monochrome image, Richardson used a highly sensitive black and white film of a type more commonly used for sports or low-light photography, which created a very grainy effect. Hasselblad 503CM, 80mm lens, Ilford Delta 3200 Professional film rated at ISO 1600.**

tungsten lamps or household lightbulbs, are weak in blue and rich in red and yellow, and produce a marked color cast on film.

Films are manufactured for use in specific lighting conditions, and the type of film you are using should, where possible, match the light source. This is particularly important with color transparency film, which is usually far more sensitive than color negative emulsions. Typically, a tungsten-balanced film is designed for a color temperature of 3,200K, while a daylight-balanced film is rated at 5,500K.

Inevitably there are situations where you find yourself shooting with the "wrong" film for the lighting conditions, especially if you have to move between indoors and out. Tungsten-type film used outdoors will have a blue cast, while daylight-balanced film used in artificial light has a yellow or orange cast. The answer is to use color-correction filters: an 85B orange filter for the former situation, an 80A blue filter for the latter. Film types are not relevant with digital cameras, of course, but even so the color balance will usually need adjusting. Most cameras have an automatic white-balance control to ensure that whites are recorded accurately.

Taking the temperature

Although daylight is predominantly blue, its intensity varies widely, according to the time of day and the weather conditions. With a clear blue sky and the subject in shadow, the color temperature may be as high as 18,000K. At dawn or dusk it may be just 3,000K, which is rather orange. The direction and intensity of the light change as the sun moves from east to west during the day. With clear skies and direct sun, the lighting conditions can be harsh, which makes the portrait photographer's job very difficult.

When the sky is cloudy or overcast, the light is much softer and the results are frequently more pleasing.

above ➤ **Shooting in direct sunlight creates areas of strong shadow on the subject's face, but here Richardson was looking for a bold feel. A polarizing filter can reduce glare from the sky or reflective surfaces. Hasselblad 503CM, 80mm lens, Fuji Provia 100 transparency film rated at ISO 80.**

6A 7 ➤ 7A

Using the light

It's difficult to get good results in strong sunlight, especially when the sun is directly overhead at midday. Subjects screw up their eyes against the glare; skin tones are bleached out, and features dissolve into contrasty pools of shadow. It's usually better to shoot in overcast conditions, or wait until early morning or late afternoon, when the light is falling at an angle. Or move the subject into an area of shadow, where the light is softer and more diffuse.

There are a number of ways to adjust the lighting, even outdoors. A reflector, positioned carefully out of shot, will throw light back onto the subject's face and fill in shadow areas. Reflectors are commonly white, silver, or gold disks of reflective material with a collapsible frame, which can be folded up and carried easily in a gadget bag. However, almost any reflective material can be pressed into service— a sheet of white card or board, silver foil, or even sheets of newspaper.

Another option is to use flash. This may seem a strange idea when the light is already bright, but a burst of fill-in can cancel out shadows and add sparkle to the subject's eyes. Flash is particularly useful if the subject is wearing a hat, which often casts the upper face into deep shadow. Fitting a diffuser over the flash head will soften the light and help to prevent harsh highlights.

It's important to study the way the light is falling before composing a shot. Using a tripod is a good habit to cultivate, and using a larger-format camera is also an excellent discipline. David Fisher used a 5x4in wooden field camera for the three shots on these pages. "Using sheet film is a very slow and deliberate process," he says. "It encourages you to think very carefully about the composition and consider all the elements—location, lighting, background—one by one. You have to think a lot about the lighting, and how to incorporate it into the picture."

Using filters

Of course, with black and white film, color temperature is not such an important issue, although it can still affect the way tones are recorded. Sometimes color filters are used with mono, particularly if the shot includes areas of sky or foliage. A red filter darkens blue skies and makes clouds stand out more strongly; conversely, it will lighten the tones of any red-colored object in the frame. An orange filter does the same job, but to a milder extent. A green filter also darkens the sky, but lightens any areas of grass or leaves, bringing out greater detail.

far left ➤ **Here David Fisher was working in soft afternoon sunlight. A large reflector behind and to the right of the camera helped to illuminate the girl's face.**

left ➤ **The lighting for this shot was soft and overcast, but a reflector to the right of the camera subtly lifted the shadows beneath the subject's eyes.**

below ➤ **Overhead cover can create attractive directional lighting. Fisher used the open sky behind him as a giant softbox, putting highlights in the subject's eyes.**

Working indoors

Using available light indoors poses certain challenges. For a start, light levels may be very low. This means shooting with a wide aperture, which leads to a shallow depth of field, making focus all the more critical. It also means very slow shutter speeds, which pose the risk of camera shake, or blur if the subject happens to move. The best solution is to use a tripod together with a cable release, to hold the camera steady. A moving subject will still record as a blur, though sometimes the photographer can turn this to advantage. For example, Paul Medley was happy to use a slow shutter speed to register movement in the cellist's bow arm.

The second problem lies in artificial lighting sources, which can cause unwanted color casts if you are using color film. Domestic lightbulbs produce a strong yellow or orange tint on daylight-type films, an effect that is more pronounced the lower the wattage of the bulb. The solution is to use tungsten-balanced film or color-correction filters; however, real problems arise if you are working with a mixture of light sources, such as domestic bulbs, studio lighting, and natural window light. It may be possible to fit filters over the light sources to balance them, or you may be able to physically switch them around or screen them off. Sometimes the color balance can be adjusted at the processing stage; sometimes you just have to trust to luck.

This was the situation faced by Paul Medley when he went to photograph top chef Raymond Blanc for a food magazine. He arrived with studio lights and a tripod, but, after a long wait, found that his busy subject could only spare him five minutes. This meant he had to shoot handheld in available light, quickly running off two 15-exposure rolls of medium-format film.

"You have to make the most of what you have," says Medley. "There was no time to set up a tripod or lights, and on-camera flash wasn't an option. I had no idea how the lighting would turn out. The main lighting was from the UV lights used to keep the food warm in the kitchen—and fortunately they turned out to have just the right color balance."

left ➤ **Paul Medley had a whole afternoon to shoot photographer Naoya Hatakayama at work in his studio, and the atmosphere was relaxed. "There was daylight coming in through two small windows—not a lot, but it was nice and diffused," recalls Medley. He used a tripod for part of the session, though this shot was handheld. Canon EOS 3, 80mm lens, Fujicolor NPC 160 color negative film, ⅒ sec at f/2.8.**

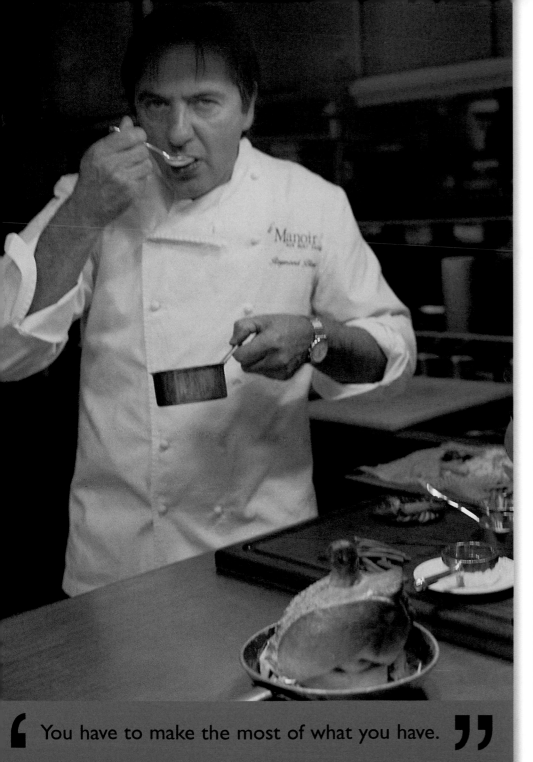

left ➤ **Artificial lighting sources often create unwanted color casts. Fortunately, when Medley was shooting Raymond Blanc, the kitchen warming lights turned out to have the correct color balance for the film he was using. Bronica ETR-Si, 80mm lens, Fujicolor NPC 160 color negative film, ¹⁄₃₀ sec at f/3.5.**

below ➤ **Medley shot this cellist at a recording session, with the aim of producing a CD cover. The subject was strongly backlit, but the overall lighting conditions were low. This forced Medley to use a slow shutter speed, but allowed him to record movement in the subject's arm and bow. Canon EOS 3, 80mm lens, Fujicolor NPC 160 color negative film, ¹⁄₁₅ sec at f/4.**

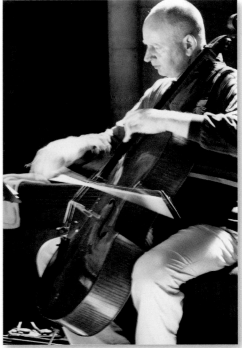

' You have to make the most of what you have. **"**

On-camera flash

Not only does camera-mounted flash cast harsh shadows, it also gives rise to the dreaded red-eye effect. This occurs when the flash is positioned on the same axis as the lens: the light bounces back off the blood vessels in the subject's eye, causing that hideous red glow. Many of today's more sophisticated compacts have a red-eye reduction feature, which blitzes the subject's eyes with a series of flashes before the shutter fires, encouraging their irises to close. However, to properly overcome the problem, you need a larger-format camera with a detachable flashgun.

Most SLR hotshoe mounts are located directly above the lens, which exacerbates the problem. However, by taking the flash off-camera, you change the angle of the light and thus reduce red-eye. You need a flash synch lead to maintain the dedicated connection between camera and flash circuitry. The flashgun can be handheld, but this is rather awkward unless you have an assistant, as it leaves you with only one hand to operate the camera. The solution is to mount the flashgun on a tripod or on a bracket attached to the camera. A hammerhead-type flashgun used with a bracket is the setup favored by many press photographers.

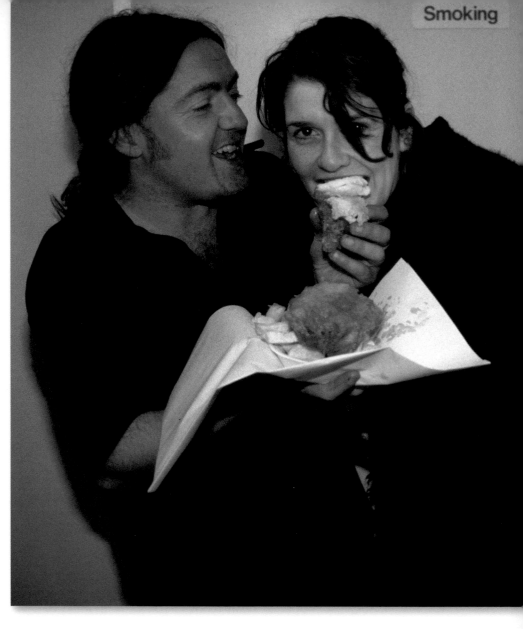

Smoking

above ➤ **Shooting a magazine commission on the subject of fast food, Paul Medley spent an evening in his local takeout joint. It was late at night, and this couple were relaxed and happy to cooperate with the camera. Because the space was small, Medley was able to bounce the flash off the ceiling, creating catchlights in the girl's eyes. Canon EOS 3, 50mm lens, Fujicolor 100 transparency film.**

12A

Diffusing the light

Flash light is frequently rather harsh. Plastic diffusers can be bought that fit over the front of the flash head, or you can improvise one of your own with tissue paper, a piece of cloth, or a handkerchief. Diffusing the light in this way reduces harsh highlights on the subject's face and tones down the shadows cast behind them.

Another good way to diffuse the light is to use bounced flash. When you buy a flashgun, choose one with an adjustable head. This can be angled upward to bounce the light off the ceiling or, in portrait format, off a nearby wall. Flash heads tilt typically at an angle of 45 or 90 degrees, and some can also be extended to restrict the spread of the light they emit. Flash bounced in this way does away with the red-eye problem, as well as giving a softer, more diffuse illumination. However, you are likely to lose around two stops' exposure, so remember to compensate for this when making your settings. And try to bounce the flash off plain white surfaces whenever possible—if the surface is strongly colored, the reflected light will transfer that color to the subject.

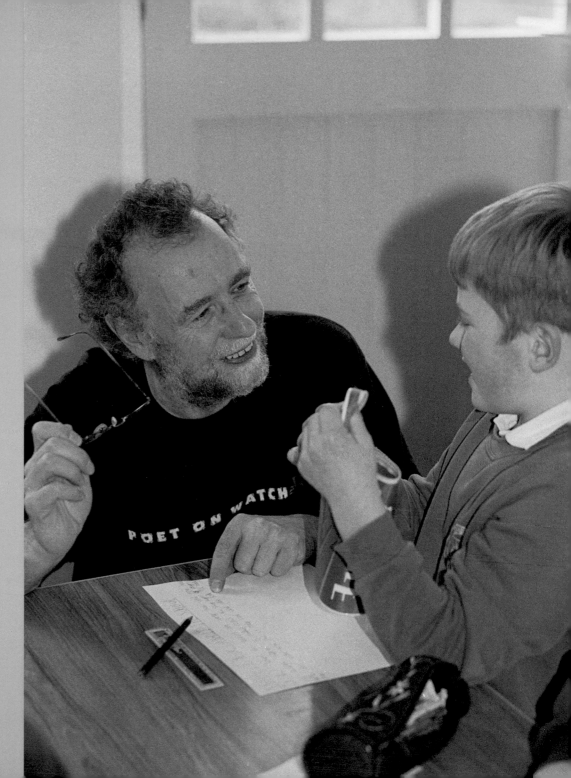

right ➤ **Medley uses available light whenever he can, but certain situations demand flash. Here he was documenting the work of performance poet Marcus Moore for an arts organization. The ceiling of the classroom was too high for bounced flash, so Medley turned the camera on its side and bounced the light off a wall instead. Canon EOS 3, 50mm lens, Fujicolor NPC 160 color negative film.**

Studio lighting

A studio setup gives you complete control over the way your pictures look, and allows you to create a range of moods and effects. Think of a studio as a stage on which you build your pictures, using light. Generally, you start with a main light, and then use others to fill in the details. Each light should have a definite role to play, rather than being placed at random. But there is no need to overelaborate—even a simple, inexpensive setup can produce impressive results.

below ➤ **David Fisher uses a large softbox as his main studio light, backed up by supplementary modeling lights and reflectors. The studio space also contains two Apple Mac-based workstations, archive filing systems, and a coffee area with a sofa where clients can relax.**

Tungsten versus flash

There are two main types of studio lighting unit: tungsten and flash. Tungsten lamps contain a fine filament of metal that heats up and glows when the light is switched on; most studio units operate at 3,200K. They allow you to see in advance how the result will look, but also generate a lot of heat and glare. Tungsten lights usually contain a built-in reflector, and the intensity and direction of the light can be controlled—either by changing the position of the bulb relative to the reflector, or by fitting an attachment over the front of the unit, such as a snoot, a honeycomb, or a set of barn doors.

Tungsten lights are turned on and off like a lightbulb, whereas flash illuminates the subject only momentarily. It pumps out light at a far greater intensity, freezing movement and allowing the photographer to work handheld. The duration of a burst of flash can be anything from 1/500 sec to the briefest millisecond. In color temperature, it is designed to match normal daylight.

above ➤ **This was a publicity shot for an actor. Fisher lit it with a softbox to the left and slightly above the camera, and a reflector to the right and slightly below. "What you want is a head shot that illustrates the actor clearly, but also gives them character and makes them look intriguing," says Fisher. Nikon D100 digital SLR, 28–70mm zoom at 70mm setting, 1/125 sec at f/8.**

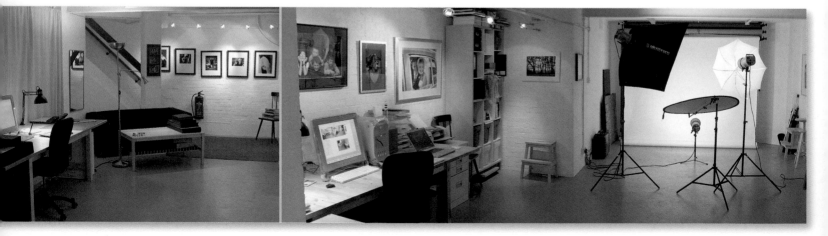

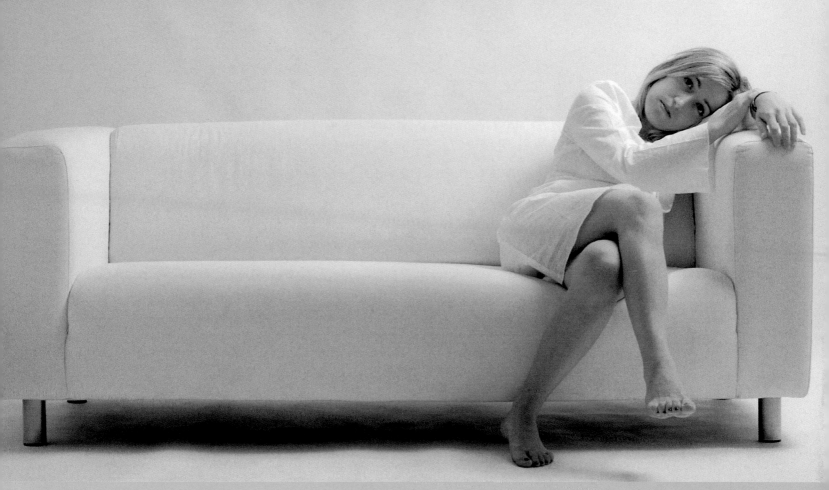

You can either work with a flashgun mounted on the camera or use freestanding studio units. The latter are mains-operated and come in two basic types. Monohead units have their own stand and have all the electronics packed into the flash head. Generator systems are more powerful, and can run several flash units at once. They are also much more expensive—you are more likely to hire this equipment than buy it. Both types usually incorporate a tungsten modeling light that lets you see how the lighting will look when the flash is fired.

There are various other types of studio lighting, including photofloods, which are high-intensity lamps designed for use with movie cameras. These operate at 3,400K and produce a blue cast on stills film, unless a pale orange correction filter is fitted. Fluorescent tubes can be used to create interesting modeling effects in black and white, but with color they tend not to give very satisfactory results.

above ➤ Here Fisher used a single studio light with a dish reflector, pointing up into the corner of the alcove, with the light bouncing off the ceiling from a distance of about 3ft (1m). A reflector on the floor in front of the subject threw some light back onto her features, though the feel is still moody and mellow. In composing the shot, Fisher placed the girl's face and legs on a rather exaggerated intersection of thirds; the original was in color. Nikon D100, 28–70mm zoom, $\frac{1}{125}$ sec at f/8.

Softboxes and reflectors

David Fisher's studio features an alcove area with walls and ceiling painted white. These help to diffuse the studio flash lights, providing a subtle fill light. They also act as a reflector, especially when studio flash is fired directly into them, providing modeling for the subject's features. A selection of paper rolls gives Fisher a choice of colors for his backgrounds.

His main illumination comes from a 40x40in (100x100cm) Elinchrom softbox, a popular accessory in the portrait studio. Softboxes come in various shapes and sizes, but all are essentially flash units fitted with a large, boxlike head and a translucent diffusing screen. When the flash is fired, they flood the subject with soft light, mimicking the effect of window light. Fisher backs

up the softbox with a handful of supplementary fill lights. He also uses Lastolite disk reflectors—white, silver, and gold—to bounce light back onto his subjects' faces to control the shadows.

A typical studio setup involves shooting with a softbox positioned to one side of the subject and a reflector to the other, both angled at about 45 degrees. This means that one side of the face is quite brightly lit, while the other is more subtly illuminated. In the studio Fisher generally uses a 35mm Nikon D100 digital camera, with a 28–70mm f/2.8 lens set at the 70mm end. Using a zoom avoids the need to keep changing lenses, reducing the risk of dust getting into the camera. He often demonstrates the kind of pose he is looking for himself, before getting his subjects to take up position.

Sense of engagement

The camera position depends largely on the subject. For men, Fisher advises shooting more or less head-on, creating a sense of direct engagement with the viewer. For women, however, a high camera angle gives a more flattering effect, accentuating the face while diminishing the body within the frame.

The girl in the black dress above is Fisher's sister, Nicky, who needed pictures for the cover of a showreel video. She wanted a background that stood out, and space within the frame to superimpose her name and some text. Fisher raised the camera up high on the tripod and angled it downward, while getting Nicky to turn her shoulders away from the light. This created an attractive contour—glamorous, but not overtly sexy.

above ➤ **A high camera angle and a face turned toward the light help to create a flattering effect. David Fisher used a softbox high and to the left of the camera and a reflector below the subject's face. A second studio light was aimed at the background. Nikon D100, 28–70mm lens.**

left ➤ **Fisher took this shot for a hairdressing magazine. The girl was swinging her head quite fast, but the studio flash froze the movement. It was lit with a softbox high up to the left and a reflector under her face, a hair light left and behind, and a spotlight aimed at the background. Nikon D100, 28–70mm lens.**

right ➤ **This shot, taken for cards announcing the couple's engagement, was a typical studio setup for Fisher: a softbox to the right of the camera and a white disk reflector to the other side. With the white paper backdrop, a single light was all that was needed. Nikon D100, 28–70mm lens.**

Creative lighting and exposure

Studio lighting doesn't need to be complicated. A couple of flash units, a reflector, and a background or two are all you need to get started. In different combinations, these simple tools can be used to create everything from a straightforward passport picture to a moody study that oozes atmosphere. As you grow in confidence, you may want to experiment with more sophisticated setups. If you feel the need for a specific piece of equipment, it's a good idea to hire it the first time around rather than buying it outright. That way, you avoid wasting money on expensive kit that may be used only once or twice before being left to gather dust.

Calculating the correct exposure is one of the biggest challenges facing the creative photographer. This applies in the studio as much as it does outdoors. Users of 35mm and digital SLRs can usually rely on the camera's built-in exposure system to give a fairly accurate reading, though adjustments still need to be made for strong highlights or shadow areas. Users of medium-format and large-format cameras regularly use handheld exposure meters.

right ➤ **This subject was just starting out as a model and wanted promotional photographs for her portfolio. Sara Richardson took the shots with the idea of including them in her own portfolio too. Nikon N90S, 35–70mm lens, Kodak Tmax 400 rated at ISO 250, lit by large tungsten softbox.**

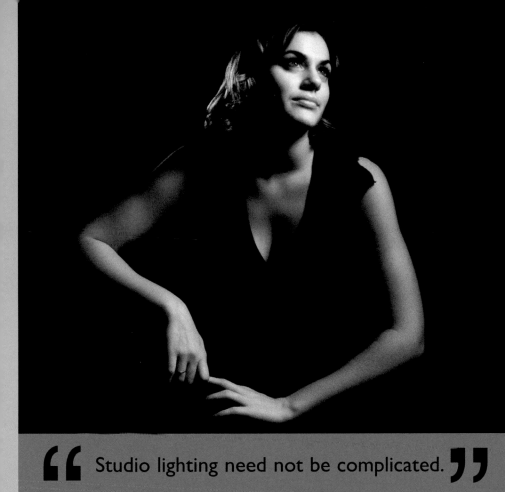

> **Studio lighting need not be complicated.**

the camera. Spot meters have a very narrow angle of view (2–3 degrees) and are used to take precise readings from small areas of the subject. Some photographers use a graycard, designed to have a standard reflectance of 18 percent, which is positioned in the same lighting conditions as the subject. Sara Richardson uses one of these, but usually sets her film at a slower ISO rating than the speed recommended by the manufacturer. "When you actually test the film, it always comes out one-third to one-half of a stop slower than the manufacturer claims," she says.

For the studio photographer using film, it's standard practice to shoot a test exposure on Polaroid instant film to check the lighting setup and exposure. With a digital camera you can see the results instantly. In addition, it's always a good idea to bracket your exposures. "Bracketing" means shooting multiple versions of the same frame, with small adjustments in exposure—perhaps half a stop or a whole stop—either side of the "correct" setting. This acts as an insurance policy against minor mistakes in your meter reading. It's not so vital with color negative film, which is generally more forgiving of minor inaccuracies, but with color transparency film accurate metering is essential.

above ➤ **For this shot Richardson used infrared film. The lighting was provided by a large tungsten softbox placed to the right of the camera position, while a second lighting unit positioned behind and to the left of the model brought out detail in her hair. Because the lighting was low, the subject's dark clothing merged with the background. Hasselblad 503CM, 80mm lens, Ilford SFX rated at ISO 250.**

These meters work in a variety of ways. Some give an average reading for the whole scene, taken from the camera position—though this method may not be accurate for a face that occupies a relatively small portion of the frame. Others require the photographer to take a reading from the brightest and darkest parts of the image, and then calculate a midrange exposure between the two. Incident light meters measure the lighting conditions from the subject's position, pointing back toward

Studio lighting terms explained

- **Acetate/gel:** a transparent sheet of colored material used to modify the color of a light.

- **Barn doors:** adjustable flaps fitted over a lighting head to shade off part of the subject.

- **Boom:** an extension arm that allows a light to be lifted high over a subject.

- **Diffuser:** a translucent material (for instance, tracing or tissue paper, an umbrella, or acrylic sheeting) used to diffuse light.

- **Effects light:** a small spotlight used to highlight a part of the subject (for example, a hair light).

- **Fill light:** extra light, either from an additional lighting head or a reflector, used to fill in shadows and even out the lighting.

- **Gobo/cookie:** a piece of metal with cutout shapes (for instance, tree branches or a spider's web) fitted over a lighting head to create special-effects shadows.

- **Honeycomb:** a grid of hexagonal cells used to increase the directionality of light from a head.

- **Key light:** the principal light source for a particular shot—the one that casts the shadows.

- **Lighting ratio:** the ratio of the key light to the fill light, as measured with an incident light meter. The higher the lighting ratio, the greater the contrast.

- **Reflector:** the dish-shaped surround to a light, or any reflective device used to throw light back onto the subject.

- **Scrim:** a heat-resistant fabric diffuser used to soften light.

- **Snoot:** a conical device that fits over a lighting head to increase the directionality of the lighting.

- **Softbox:** a large diffused lighting head, the studio photographer's standby, which comes in many different shapes and sizes. It can be rigid or made of fabric; also known as a windowlight.

- **Strobe:** electronic flash.

- **Tungsten:** an incandescent lighting source. Photographic tungsten lights run at 3,200–3,400K, while domestic lamps run at 2,400–2,800K.

- **Umbrella:** this may have a white, silver, or gold interior for use as a reflector, with light directed into the umbrella; or it may be made of a translucent material to act as a diffuser, with light shining through the umbrella.

left ➤ **The lighting for this shot was complex, with Stefan Hester using five different lights in all. The main light was a softbox positioned in front of the subject, illuminating his face. In the middle of the softbox, Hester arranged a spotlight fitted with a grid to add some extra modeling. He rigged up another spotlight on a boom above the subject's head, aiming it at the background. The final two lights were placed level with the background, equidistant to the left and the right, to illuminate the sides of the subject's face. Mamiya RB, 90mm lens, $\frac{1}{125}$ sec at f/16.**

below ➤ **To create a moody atmosphere, Sara Richardson used a black background and kept the lighting low-key. The only illumination came from a large tungsten softbox. Nikon N90S, 35–70mm lens, Kodak Tmax 400 rated at ISO 250, Profoto softbox.**

RVP ▷ 11 RVP ▷ 12

Formal portraits

❝ There is something about a properly organized,

RVP ▷ 13 RVP ▷ 14

professionally shot portrait session that remains special. **"**

Formal portraits

Babies and toddlers

People commission formal portraits for a variety of reasons. It might be to mark a particular milestone in a person's life: a christening, a first communion, or a bar mitzvah; in later years, graduation from college, followed by engagement and marriage; and later still, perhaps, retirement. More often than not, however, people simply want a record of themselves and their families at a particular moment in time—an image they can look back on and treasure in years to come.

When it comes to formal portraits, families are undoubtedly the major clients. These days nearly every family has a camera that is used to record vacations and the kids as they grow up, but there is something about a properly organized, professionally shot portrait session that remains special. These are the pictures that people frame and hang on their walls, and the ones they most often choose to send to relatives living far away. The formal portrait picture has an authority, and a sense of permanence, that the home-produced snapshot usually lacks.

A formal portrait does not have to be stiff and posed. This is especially true of pictures of children: parents no longer want old-style portraits, with youngsters grimly attempting to sit still and smile for the camera. Most people now prefer a more natural style, whether in the studio or—increasingly—on location.

Go with the flow

Babies and toddlers can be difficult to photograph. Small children react in different ways to the presence of a stranger with a camera.

above ➤ **For any subject, communication is key, but it's particularly important with small children. "You can't talk to a baby about its interests, so it's really just down to you and the subject. You have to have true communication, and this is what the viewer ultimately sees," says Stefanie Herzer. Canon EOS IDS with 24–70mm lens, set at ISO 100, ¹⁄₆₀ sec at f/7.1.**

left ➤ **"High-key lighting is good for small children, especially girls," says Herzer. "This was from my very first high-key studio session, using a white paper roll as a background. One of my studio props is a pink chicken that dances the chicken dance, and Gianna was excited because she'd just caught the chicken." Canon EOS IDS with 70–200mm lens, set at ISO 100.**

right ➤ **Here Herzer used "form fill," which involves placing the main light and fill light on the same side of the subject. This creates a "wraparound" effect, which is quite flattering to faces. Canon EOS IDS with 70–200mm lens, set at ISO 100, ¹⁄₁₀₀ sec at f/10.**

Some enjoy being the center of attention and will act up for the photographer, while others are extremely shy. Toddlers are constantly running around exploring their environment, and can be particularly exasperating.

All young children are subject to rapid changes of mood. There's no point in trying to force them to smile or pose—they will get bored and restless very quickly, and some may even turn defiant. Make sure the child isn't tired or grumpy, or suffering from a cold, when you start the session. A good time to photograph babies is after they've had a feed or a sleep, but be prepared to abandon the session if the child is not cooperating. It's better to reschedule a shoot than attempt to force a reluctant child to "perform" for the camera.

It's often hard to get a small child to look in the right direction, but a good ploy is to make a funny noise to provoke a response. Props such as balloons, balls, and soap bubbles will absorb their attention and occupy their hands. However, don't give them too many toys to play with—this will only be confusing for them and will make the shot look cluttered.

Try to work quickly and confidently in short bursts, aiming to capture the moments when the child is relaxed and happy. Be sure to get some basic shots first, before trying any more ambitious poses, and factor in plenty of rest breaks. If a child gets upset, stop the shoot for a while and let him or her calm down. With very young children it's always best to have a parent on hand, both for safety's sake and to help comfort and reassure them. Sometimes the presence of an older sibling can also be helpful.

Older children

When you are commissioned to shoot pictures of children, take time beforehand to discuss with the parents the kind of image they have in mind. In general, parents want shots that show their children looking smart, adorable, and—above all—happy. However, there are many different ways of achieving this: some parents prefer a cute, romanticized take on childhood, while others favor a more lifestyle-oriented, aspirational image, perhaps inspired by editorial and fashion images in clothing catalogs and magazines. If you specialize in a particular style, make this clear from the outset. There's no harm in trying out different styles once in a while, but avoid anything too experimental or off-the-wall. If parents don't like the portraits you produce, they won't be keen to pay you for them.

Children love to dress up, but overelaborate costumes or stiff suits can make them appear wooden, and shots often look more natural if they are wearing casual clothes. Try to dissuade parents from too many changes of costume during a session, as this just takes up time and you may lose the cooperation of the child. Simple colors and patterns work best, and the background too should be clean and uncluttered. A prop can help set a mood—hats work well and are also fun for a young subject to try on.

right ➤ **Balanced lighting is particularly important when working with children, as the exposure remains fairly consistent over a wide area, even if a child is running around the studio. Stephen Smith used a Hasselblad H1 with an Imacon digital back; $\frac{1}{120}$ sec at f/5.6.**

Handling the parents

With older children, it's sometimes a help to have mother or father around, as their presence can put the child at ease and help him or her relax. But on other occasions their presence can be distracting and, if this is the case, it's best to encourage the parent to fade discreetly into the background or even leave the room for a while. It's important that you maintain control over the session. Some parents can't help issuing instructions to their child, which can be counterproductive and often quite irritating for the photographer. Be firm, but remain polite and diplomatic—after all, the parent is the client and is paying you to provide a service.

Young children do not generally stay in one position for very long, so it's important to work fast. Make sure that you're thoroughly familiar with your equipment and, before each shoot, test the cameras, lenses, and lights you are planning to use. If you're working in your own studio, have all the equipment (including backgrounds) set up and ready to go before clients arrive. It's a good idea to standardize your camera settings as much as possible and to use the same settings for each shoot—that way you won't be worrying about shutter speeds and apertures once the session starts, but will be able to concentrate completely on the child. With a hyperactive youngster running around, you can't afford to be fiddling with meter readings and lighting setups.

above ➤ **For studio pictures of children it's best to keep the lighting soft and even and backgrounds clean and uncluttered, to help concentrate attention on the face. Stephen Smith lit this shot with two flash heads with umbrellas pointed at the background, and two softboxes either side of the subject. Hasselblad H1 with Imacon digital back, $\frac{1}{120}$ sec at f/5.6.**

Act natural

With children more than anyone, it's essential to establish a rapport if your pictures are to succeed. Kids are not very good at hiding their feelings: if they don't like you, they'll show it, and this will be all too apparent in the end product.

Try to put children at ease from the start of the session. Some are intimidated by a formal atmosphere and lots of camera equipment and studio lights, so keep things as simple as possible. If a child brings a favorite toy along to the session, this may help him or her to feel secure and to relax in front of the camera. Other kids may be fascinated by the new environment and want to know exactly what's going on. Let them get involved in the shoot—perhaps ask them to move an item of equipment into place, let them look through the camera, and even fire off a frame or two themselves. This makes them feel

above and left ➤ **I shot Alexander and Barnaby on a relatively bright morning in late fall. They'd found the sticks while walking along a river and posed spontaneously with them when the camera appeared. Using a zoom lens allowed me to frame the shots quickly, while pre-selecting the camera's "Portrait" mode automatically gave a wide aperture that threw the background of fallen leaves out of focus. Nikon F90X, 28–105mm lens, Fujicolor 200 print film, 1/125 sec at f/3.5.**

above right ➤ **Bi Scott has tried several variations on this shot. This was taken at a wedding, at the end of a long, hot summer day. Canon EOS 300D with 18–55mm lens, set at ISO 200.**

part of the process and much more ready to cooperate. Of course, you mustn't let them run riot. Safety is paramount: first theirs, then that of your equipment.

Your aim should be to capture the personality of the child, so let them be themselves as far as possible. It's no good trying to force them to sit still. Instead, treat the whole session as a game. Tell a joke or make a funny noise; get the child to say something silly; or pretend you can hear a noise somewhere and ask them to listen for it. Don't try to force a smile if one isn't forthcoming—sometimes a pensive expression works better.

Capturing a fleeting pose

Kids have a short attention span, so you need to work fast. You also need a great deal of patience. Be prepared to shoot plenty of frames—film is relatively cheap and, if you're using digital, you can simply delete the outtakes. If you keep your equipment simple and eliminate distractions, you'll be ready to capture a fleeting pose.

On location, kids can run around and let off steam, which gives you the chance to capture spontaneous, natural images. Try to blend into the background and let them do their own thing. Reportage-style pictures often work well, and handheld 35mm equipment is ideal for this.

Rather than trying to get your subjects to stand still, or following them around, step back and use a zoom to frame shots from a distance.

Always be aware of the background, and try to keep it simple. Expanses of leaves and grass work well in summer, as do carpets of dried leaves in fall and snowy backdrops in winter. You can shoot outdoors all year round, but do make sure the child is wrapped up warm. A cold, unhappy child does not photograph well.

Children at home

When David Fisher goes to a client's house to photograph their children, he spends the first 15 minutes or so simply getting to know the youngsters and encouraging them to relax. "A good way of doing this is to get them to show you around the house—you get into their world and it makes them feel they're the center of attention," he explains. "Most kids are very proud of where they live and love showing people around. It gives you an idea of what's important in their lives and, just as usefully, it allows you to scout out the house for locations and lighting."

The brother and sister in the black and white portrait showed Fisher all over their home, including their treehouse. They also introduced him to their dog. "Pets are great," says Fisher. "They help the children to relax and be themselves. Here the dog is part of the picture, but it's almost incidental, like a prop."

Getting down to their level
For the color picture of the five siblings, the guided tour of the house led Fisher to choose the lounge as the best location for the session, partly because of its size and partly because of the way the light was falling through the large

below ➤ **Working with five restless children, David Fisher had to shoot about 40 frames before he was sure he'd got the picture he wanted. When he printed it up, he cropped it to a semi-panoramic format with a ratio of 2:1, eliminating some of the background. Nikon D100, 50mm lens, handheld, 1/500 sec at f/2.8.**

right ➤ **Here sunlight from a window was bouncing up off the kitchen floor. Fisher included the dog in the picture to put the children at their ease. Mamiya RB67, standard lens and tripod, ISO 400 film, 1/60 sec at f/3.5.**

> " It's a good option to shoot children at their own level. "

Alternatively, aim to capture them hanging out and looking cool. Teenagers like to display attitude, and a simple prop such as a pair of sunglasses can add greatly to the impact of a shot. Friendships are enormously important for this age group, so shooting groups of friends can also be a fruitful avenue.

right ➤ **Scott took this shot of her son Anton on location, during a boating trip. The light reflecting up off the water provided soft, even illumination. Canon EOS 5, 28–105mm lens, Kodak Gold 200.**

below ➤ **Scott was aiming to catch this young woman in an intimate, confidential mode. There was plenty of natural daylight to illuminate the shot. Canon EOS 300D with 18–55mm lens, set at ISO 200.**

" Try to create an upbeat, lively atmosphere. "

Character portraits

Character is a very difficult quality to define. Everyone has it to some extent, but certain people exude it to such a degree that they cry out to be photographed. In the family context, grandparents and older aunts and uncles make excellent subjects for character portraits. Elderly people's features may have lost the freshness of youth, but the marks and wrinkles left by experience and the passage of time speak volumes about that person's life, and often have a beauty of their own.

Sometimes the picture works best when the person is portrayed in a familiar environment, where they are surrounded by comfortable reminders of a full and happy life. Other pictures work better when you focus in close on a face, isolating it from the background. Elderly people are sometimes more self-conscious than the young in front of a camera, and it may take some time to put them at their ease. Encouraging them to talk about their lives is a good way to break the ice. People can become very animated when recalling past events, and their animation provides excellent opportunities for the photographer.

Local color

For location or travel photographers, character portraits are an important staple. People who work outdoors—such as fishermen and farmers, with their weatherbeaten faces—are a favorite choice. Market stallholders and shopkeepers, bus and cab drivers, waiters and tour guides: all make potentially interesting subjects, especially if they are wearing colorful local clothing or are framed against an exotic background. However, just because someone has a striking face, don't assume that they're keen to be photographed. Seek permission as you would with anyone else, and treat your subject with respect.

left ➤ **With soft overhead lighting and the sun setting behind, Stefan Hester posed his subject outdoors against a white window shade, and cropped in tight. The slow shutter speed caught some movement in the man's mouth, as he was speaking at the moment of exposure. The catchlights in his eyes came from sunlight reflected off a parked vehicle behind the photographer. Mamiya RB, 150mm lens, tripod, ⅕ sec at f/5.6.**

" The marks and wrinkles left by experience and the

The man in Stefan Hester's picture had been a boxer in his younger days, fighting under the stage name of Warlock. Hester struck up a conversation as he passed by in the street, and they got on so well that they bought a couple of beers and spent an hour and a half together, just talking. Both were amused by the fact that Warlock lived in a very cheap hotel in St. Louis, but was wearing an extremely expensive hat. For the portrait, Hester cropped in close on the man's face, trying to convey some of the aggressiveness he'd displayed in his youth.

left ➤ **Bi Scott shot meadowman Richard Morin in a number of different settings around the college where he works. "He hates having his picture taken, so the bars were a safety precaution!" says Scott. Canon EOS 5, 28–105mm lens, Kodak Gold 200.**

passage of time speak volumes about a person's life. „

Family groups

The group shot is one that often ends up framed, hanging on the wall or in pride of place on the mantelpiece in the family home. It is also a favorite for sending to relatives—grandparents and distant aunts and uncles—especially at Christmas time. For the photographer it's worth putting special effort into this type of portrait, especially if there is the prospect of selling multiple reprints.

There are many different types of family group. The most common is the nuclear family unit of parents and children. However, variations include groups of siblings on their own; father and son or mother and daughter (and vice versa); and children with their grandparents.

For special occasions, such as a family reunion or a landmark birthday, whole crowds of uncles, aunts, and cousins may also get in on the act. Obviously the more extended the family, the greater the number of permutations.

Before you shoot a family session, spend time talking with the client (this will often be the mother), getting to know the family and finding out what they want. Most people really require you not simply to take their picture, but to tell their story. Find out about the family's activities and interests, and offer suggestions for locations outside the home. One way to make a family portrait special is to turn it into an event—for example, traveling to a favorite local park, theme park, or building of interest, or a regular place of worship.

Encapsulating a family

Try to suggest a style that captures the client's personality—whether it be classical, romantic, photojournalistic, or whimsical. You will have your own specialist areas, but it's important to give the client as much choice as possible. Visiting them at home will give you a better idea of what is likely to appeal to them. You should always be thinking of the end product and attempting to visualize how the finished picture will look hanging in the home. Practiced photographers are happy to make suggestions on details such as coordinating the color of the clothes the clients intend to wear with the home décor.

When it comes to shooting, aim to get your "banker" shots of the whole family together first, then try out different combinations of individuals. To some extent you have to choreograph groups, but more often than not this simply involves getting people vaguely in the right positions and then letting them art-direct themselves. If the clients want shots done in formal clothing (for instance, to mark an engagement or a twenty-first birthday), do these first, then encourage them to dress down as the session progresses. Often casual shots look most natural and will be the ones clients like best.

left ➤ **Stefanie Herzer's first ever portrait commission was from her next-door neighbors—and it became an annual event. The first session took place on a remote beach on the Pacific coast. "There are a few things in this shot I would change now. For example, you shouldn't really have the youngest girl next to Mom." Canon EOS D30, 28–135mm IS lens.**

above ➤ The following year the Bukowski
family posed on Baker Beach in San Francisco.
"Beaches are not great for photography,
because the light is harsh and people tend to
squint," says Herzer. "Overcast conditions are
best." Canon EOS D60, 28–135mm lens.

left ➤ By the third year the Bukowskis were
really entering into the spirit of things. "This
was shot in their home, in quite a small space,
so I used a single flash and umbrella and a
wide-angle lens," explains Herzer. "I only took
about 20 shots, and there wasn't one in which
all the individual expressions were perfect.
The two children at the front were actually
stitched into this frame using Photoshop.
This is something you can also do with formal
group shots at weddings." Canon EOS 1DS,
24–70mm lens, off-camera flash.

formal portraits [65]

3A 4 ➡ 4A

Pets

People often consider their pets part of the family, and many portrait and wedding photographers see pet pictures as a natural extension to their business. Cats and dogs are the most usual subjects, but you may also be called on to photograph horses, hamsters, rabbits, and even parrots. Pet portraits can be taken either in the studio or on location at the client's home.

Photographing animals is rather like working with small children. You have to cajole and encourage the subject and be ready to snap a fleeting expression or a turn of the head. You must work fast and have a lot of patience: usually it takes many attempts to get a shot that works. Sometimes it helps to pose a pet with a family member: a shot of a child holding a favorite pet is very appealing, and the setup has the added advantage of keeping the animal relatively still.

left ➤ **It's a good idea to try lots of different framing options when shooting pets— medium-range, zoom shots, and even big closeups where some of the face is out of focus. Stephen Smith was photographing a client's children, and he invited her to bring the family dog into the studio as well. He lit the shot with two flash heads with umbrellas on the background and two softboxes aimed at the subject—the same setup he uses for children. Hasselblad H1 with Imacon digital back, ½₀₀ sec at f/5.6.**

When an animal is running around on its own, be prepared for a lot of "misses." Select a small aperture if you can: the greater the depth of field, the better your chances of getting a sharp shot. Using a fast film gives you a smaller aperture to work with. A fast shutter speed helps to freeze movement, though a little blur is acceptable, provided the animal's face is sharp. Always focus on the eyes: even with a shallow depth of field, the shot will work if the eyes are sharp. As with kids, it can be a good idea to get down low and shoot at the animal's eye level, rather than standing over them and shooting from above.

Posing animals

In the studio, keep the lighting even, so that it remains constant even if the animal moves out of position. Plain backgrounds are best, but they should offer a certain amount of contrast: don't shoot a black dog against a black background. Dark fur absorbs light, so a black dog needs more illumination than a white one. A flash head placed to one side will help to highlight the texture of the animal's fur. Smaller animals, such as puppies, kittens, or hamsters, can be contained in a box a few feet square. This gives you more control over framing and lighting, and even allows you to build small sets for the animal to "pose" in.

Dogs are more obedient than other animals, and it helps to have the owner on hand to attract their attention by talking to them or by dangling a toy just out of shot. Dogs respond to other animal noises, so—however silly it sounds —try barking or meowing at them to encourage them to prick up their ears. Cats, on the other hand, are far less likely to cooperate in a studio setting. Having the owner nearby stops them getting nervous, but it's often best to shoot them in their home, where they feel more comfortable. One last point: hygiene is important, so keep plenty of newspaper and a mop on hand to deal with the inevitable accidents.

left ➤ **If the animal is free to run around, you need to be all the more patient. Use a long lens or a zoom, so that you can capture shots at a distance. Here Smith pictured his own dogs (and friend) on a beach. Nikon D1, 80–200mm lens, ½₀₀ sec at f/8.**

" Photographing animals is rather like working with small children. "

Weddings

Along with studio work, weddings are the mainstay of the commercial portrait photographer. They are also a proven training ground for the aspiring pro. Once you've demonstrated you're at least halfway competent with a camera, it's surprising how many of your friends and family will want to entrust you with the photography at their own marriage ceremonies.

This can be daunting for the first-timer: flattering though it is to be asked, you are suddenly landed with a big responsibility. There are no second chances in wedding photography: you are expected to take a perfect set of pictures on the day. In addition, you have to deal cheerfully with crowds of strangers and, afterward, produce professional-looking albums and advise on enlargements and reprints. This can be very stressful—enough to make the inexperienced photographer as nervous as the bride and groom. However, by the time you tackle your third or fourth wedding you should be taking the challenge in your stride.

The traditional approach to wedding photography is formal, with the bride and groom, and groups of relatives, posed rather stiffly on the church steps. For this style of photography it's customary to use a tripod and a medium-format camera, to get the best possible quality in the print. Nowadays, however, many couples prefer a more contemporary—and far less formal—reportage style. To achieve this the photographer roams at will, trying to blend into the background and snapping guests unobtrusively; 35mm is the natural choice for this style of photography, which lends itself well to black and white.

Whatever style they shoot in, wedding photographers generally use color negative film in preference to color transparency. They have to work quickly, and print films are far more forgiving of minor exposure errors. Some photographers prefer digital, finding that it gives them a great deal of flexibility, both in recording the event and in post-production.

left ➤ **David Fisher used soft daylight falling through the window to light this shot, working with a fast film to give himself a larger aperture. Signing the register is a part of the ceremony that you will normally be asked to capture—though some churches and register offices are quite strict about what you can photograph, and you may only be permitted to capture the bride arriving at the ceremony and the couple leaving afterward. Nikon F100, 50mm lens, Fujicolor NPZ 800, 1/125 sec at f/2.8.**

right ➤ **A classic shot of the bride and groom leaving for the reception—but it was marred by a distracting reflection of an uncle in the bodywork of the vehicle. Fisher solved the problem by airbrushing him out using Photoshop. Nikon F100, 50mm lens, Fujicolor NPH 400, 1/500 sec at f/2.8.**

Planning the day's shoot

Sit down with the bride and groom well before the big day and discuss in detail what they require, in terms of both style and content. Some couples prefer to keep things low-key and opt for "bare bones" coverage, while others want every moment recorded in lavish detail. If you're shooting documentary-style, you might follow the bride through the day, starting off at home as she prepares for the ceremony and culminating in candid snapshots of the guests letting their hair down at the reception.

Whatever the approach, there are certain key moments—the bride's arrival at the church, the couple walking down the aisle, and their first kiss as man and wife—that you should aim to capture without fail.

You need to find out whether you can shoot inside the church or register office, and establish what family groups are required. It's important to scout out both the wedding and reception locations beforehand, to get an idea of how the day will unfold and what backgrounds will be available. On the day itself, it helps enormously

if you can enlist the help of the best man or ushers in organizing the lineups for the group shots. Work as quickly as you can: guests won't like milling around aimlessly, waiting for you to finish. Finally, dress smartly, remain unfailingly polite, and avoid the champagne until all the important shots are in the bag.

3A 4 ➡ 4A

Capturing the mood

Weddings are an important part of David Fisher's business, especially in the summer months. He works with 35mm, using color negative films that are designed specifically for portraiture outdoors. If the client prefers black and white for certain shots, he can scan the negatives back at base and convert them to mono using Photoshop. He carries two cameras, one for backup in case of failure, and to avoid missing important moments when he's changing film. He has a small selection of lenses that covers all eventualities: a 50mm with a wide (f/1.4) aperture, a 28–70mm zoom, and, for longer shots, an 80–200mm f/2.8 image stabilizing (IS) lens.

8A 9 9A

left ➤ **The two main difficulties with group shots are getting everyone looking in the right direction and a clear view of every face. David Fisher shot from an upper floor of the venue, with the camera angled downward to avoid flare. The group was backlit by the sun, but the light bouncing back off the building provided fill-in for their faces. Nikon F100, 28–70mm lens, Fujicolor NPH 400.**

Only rarely does Fisher use flash when shooting a wedding—he much prefers to work in available light. "I'm a firm believer in using what's there, to catch the ambience," he says. "That's true even of dull and rainy days. Actually, it's easier to shoot in overcast conditions than on a sunny day. When the light is bright, you have to worry about the angles more, which isn't the case when the conditions are dull."

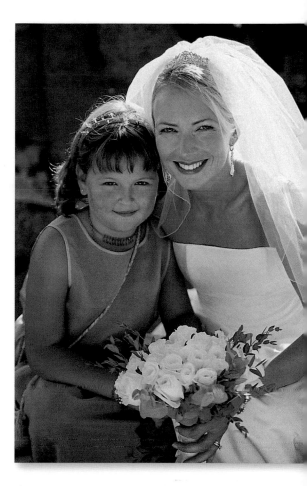

Wedding checklist

It is essential to record certain parts of the day, but others are optional. Discuss the exact requirements with the bride and groom beforehand.

- Bride preparing at home (including shots of bridesmaids and page boys)
- Church doorway: bride and groom kissing, guests throwing confetti

- Candids of guests arriving at the church or register office
- Candids of bride and groom being congratulated

- Groom, best man, and ushers greeting the guests
- Group shots on church steps or in churchyard, if requested

- Bridesmaids and bride's mother arriving
- Bride and groom being driven to reception

- Bride and father arriving at church door
- Bride and groom greeting guests

- Church interior during ceremony, if permitted (but don't use flash)
- Group shots: small family groups and a large group shot, if requested

- Signing the register
- Interior of reception venue: place settings, flower displays, and the cake

- Bride and groom walking down the aisle
- Candids of guests sipping champagne

above ➤ **Once the ceremony is over, the participants unwind and it's time to seek out more informal, relaxed shots. Here bright sunlight was falling over the bride's shoulder, so Fisher placed a reflector in front of her and the bridesmaid to throw some of it back onto their faces. Nikon F100, 28–70mm lens, Fujicolor NPH 400.**

Fashion and beauty

Fashion and beauty photography lies at the opposite end of the spectrum from character portraits (in which wrinkles and blemishes are a virtue) and candids (where the idea is to catch the subject offguard). Instead, the photographer is aiming to produce an idealized image of the subject, creating the impression of a flawless complexion and a perfect figure. Nine times out of ten the client for this type of photography will be female, and she will want the image for personal consumption, purely to make herself (and perhaps her partner) feel good. However, the category also includes men who have a professional interest in their appearance, such as singers, actors, and male models.

Creating a beauty image involves close collaboration between photographer and subject, and careful planning in terms of lighting, colors, and mood. The work of the top fashion photographers is a good place to start, with magazine covers and cosmetics ads providing inspiration. Some clients want a glamorous studio portrait, with high-key lighting and lots of makeup, while others prefer a softer, more romantic image. Some go for a contemporary lifestyle approach, choosing an outdoor setting. Others like the edgy fashion feel created by cross-processing (in which color transparency film is developed in color negative chemicals).

right ➤ **Sara Richardson took this shot in her studio, using a white background, with two softboxes to illuminate the subject. Mamiya RZ67, 80mm lens, Ilford FP4 125 film rated at ISO 100, Profoto lighting kit.**

Professional models are highly paid partly because of their physical beauty and partly because they have the knack of interacting with the camera. Not everyone possesses these qualities, so you should constantly encourage your subject, with the aim of boosting his or her confidence. Always try to emphasize the best features. Top social photographers work closely with stylists and makeup artists, allowing them to try out different looks in the studio as the session progresses. For a client, having their hair and makeup done makes them feel pampered and helps them relax in front of the camera.

Tricks of the trade

There are plenty of dodges to disguise less-than-perfect features. For example, unless your subject has a supermodel figure, suggest that he or she wears loose, flowing clothes rather than a skin-tight outfit. Sometimes getting the subject to lie on the floor can create a more flattering angle. Someone who is facing the camera head-on can look broader than if they are standing at an angle, so turn your subject slightly sideways. If the head is pushed forward, it helps to avoid the suggestion of a double chin. If the person is short, crop the picture at the thighs rather than shoot full-frame—this will make them look taller.

Cover facial blemishes with lots of makeup, and set the lighting so that you overexpose slightly to burn out some of the detail. Blemishes can also be removed (or at least reduced) at the post-production stage, using an image-manipulation package such as Photoshop.

below left ➤ Richardson chose a pure fashion approach for this image, taken in Santa Barbara. She pushed the film by one stop during processing to boost the contrast. Hasselblad 503CM, 80mm lens, Fujichrome Provia 100F, rated at ISO 80, Profoto lighting kit.

below ➤ Richardson posed her model so that her smart clothes contrasted with the weathered background. Hasselblad 503CM, 80mm lens, Fujichrome Provia 100F rated at ISO 80, Profoto lighting kit.

RVP ▷ 11 RVP ▷ 12

On location

" Photographing in places you haven't

RVP ▷ 13 RVP ▷ 14

been before instantly gives you new perspectives. **"**

On location

Be prepared

Location work covers a vast range of styles and subjects—everything from corporate executives in the boardroom to a fashion shoot in the desert. The common characteristic of all location work is that you are operating away from home, and so have to carry all your equipment with you. This requires careful planning. As well as cameras, lenses, tripods, and flashguns, you should pack plenty of film. Always take more than you think you'll need: for any photographer, running out of film is the cardinal sin. The same goes for the digital photographer: make sure you have backup memory cards with plenty of spare capacity. You should always check beforehand that your equipment is functioning properly, and carry spare batteries for each item. A dead camera means the end of the session.

Atmospheric influences

Locations play an important role in Stefan Hester's portraits. He lives in the old industrial town of St. Louis, Missouri, and is working on a project to document the decline of this once-thriving place. "A photograph may be of an individual, but the influences on that individual are social, political, and historical," says Hester.

His method of working is to drive around until he finds an interesting part of town, then get out and walk, hauling his equipment on a little cart. Normally his kit consists of just a camera and a tripod, but sometimes he also carries a battery-powered flashgun with its own stand. "I like to explore by walking, not driving, as it gets you up close to your surroundings, and allows for random interaction with potential subjects. Photographing in places you haven't been before instantly gives you new perspectives. You don't have to go to another state or a different country—it's often more inspiring simply to go to the other side of town."

When he spots an interesting person, he finds a pretext to strike up a conversation. He'll chat for about 20 minutes before raising the idea of a portrait: this helps to relax the subject, and gives Hester a chance to find out something about them. Most of his work is done in the summer months; in winter, people are less willing to stop and give him time.

Although he sometimes shoots on medium-format, he prefers to use a 5x4in camera. Not only does this allow him to be more creative, but it's more of an experience for the subject. He nearly always uses a tripod. "The tripod is not just a tool to steady the camera—it slows me right down, and forces me to think about what I'm doing," says Hester. "It's easy just to click away, but that's laziness. Using 5x4in forces you not to be lazy."

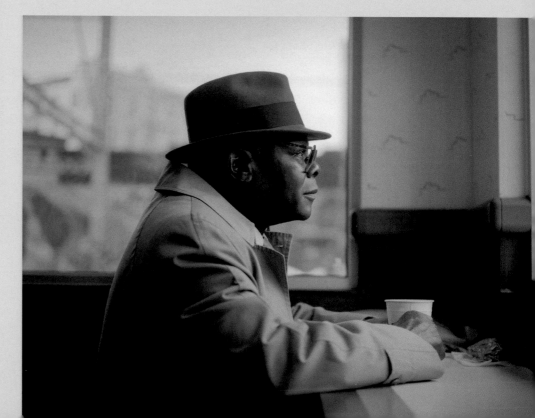

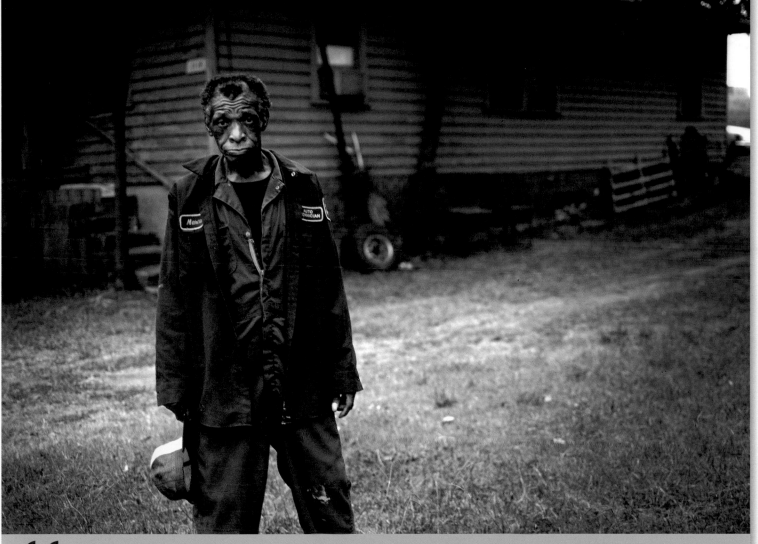

> **A photograph may be of an individual, but the influences on that individual are social, political, and historical.**

left ➤ **While exploring the Bronx in New York, Stefan Hester met this man having coffee on his way to church. The location was an uninspiring fast-food restaurant, but Hester framed the shot so that most of the background was window. "I took his photograph for the same reasons I ended up talking with him for close to an hour—he appeared kind, thoughtful, and had an air of determination." Mamiya RB, 90mm lens and tripod, ⅓₀ sec at f/5.6.**

above ➤ **Hester was photographing a disused gas station in Atlanta, Georgia, when this former employee came to ask what he was doing. Mamiya RB, 90mm lens, handheld, Fujichrome Provia 400F, ⅟₆₀ sec at f/5.6.**

5A 6 ➤ 6A

People at work

Pictures of people doing things are always interesting, and the workplace provides a rich seam of photographic opportunities. For most individuals, work plays a hugely important role in their lives, giving them an identity and a purpose, over and above earning the daily crust. Most people are proud of what they do and are happy to be photographed doing it. Indeed, some may even feel more "themselves" at work than they do in their home environment.

The variety of workplaces is endless, but all have the potential for pictures. You might be commissioned—for example, to take shots for brochures, promotional literature, or a newspaper or magazine—or you might decide to take pictures as a personal project. Whatever your purpose, remember that people are usually very busy, so work quickly and try not to take up too much of their time. It helps if you have some previous examples of your work to show them, so that they get an idea of what you're trying to do.

8A 9 9A

Work in motion

You can shoot people in static poses, but it's often more interesting to capture them documentary-style as they go about their daily business. Black and white can be highly effective for this type of photography. Look for interesting backgrounds, and include objects that illustrate what the job is about or that say something about the individual. Make sure your subject has something to do with their hands: ask them to explain an aspect of the job to you, then start snapping as they demonstrate it.

An interesting approach is to construct a narrative showing different aspects of someone's working life. Try to visualize it as a series of pictures in a magazine story, and imagine how the images might fit together on a page. Ensure that shots complement one another, and vary the way you frame them—closeups, long shots, wide-angles, and so on—to create momentum. If you're working in color, try to vary the tones by seeking out a variety of backgrounds. It adds to the story if you include detail shots—for example, closeups of a worker's hands as he or she performs a task. These might not have much impact when viewed in isolation, but they can make a valuable contribution to the bigger picture.

above left ➤ **David Fisher undertook a project to document the various businesses based in a single street. Working handheld in natural light, he approached each picture by first establishing where the light was best, then deciding on a background against which the subject could be framed. Nikon F100, 50mm lens, Ilford HP5 Plus, ⅟₆₀ sec at f/1.8.**

above ➤ **This man was the superintendent of a care home. "I printed the shot on a fiber-based paper with a warm tone—it's much nicer on the skin tones," says Fisher. Nikon F100, 50mm lens, Ilford HP5 Plus, ⅟₆₀ sec at f/2.8.**

right ➤ **For this shot of a waiter in an Indian restaurant, Fisher leant on a counter, bracing his elbows to hold the camera steady. Nikon F100, 50mm lens, Ilford HP5 Plus, ⅟₃₀ sec at f/1.8.**

The corporate environment

Big companies provide rich pickings for the portrait photographer. Corporate brochures, annual reports, in-house newsletters, and awards ceremonies generate a constant demand for staff pictures, while many companies maintain a library of portraits for supply to business magazines, for example when an executive provides a quote for an article or makes the news by changing jobs or winning an award.

The corporate environment can be rather bland, and business portraits often suffer from an excess of staginess. It's hard to make people look interesting in the standard-issue business outfit, and trade publications are littered with cheesy

pictures of executives sitting behind a desk, or holding a product up to the camera, or posing stiffly in a hard hat on a construction site.

When shooting on location, look for creative ways to add interest. Offices tend to be short on good backgrounds, but you can get around this by taking the subject outside. Other ploys include shooting in big closeup, or with an extreme wide-angle to include personal office space; tilting the camera at a dynamic angle; or (for scientists and IT specialists) using lights fitted with colored filters to create a high-tech glow. However, don't go too far over the top or the picture will be unsuitable for its target audience. In most cases, people will be very busy and won't be able to spare you much time, so do your research

right and below ➤ Bi Scott's brief was to capture a look that was accessible and trust-inspiring, but not too informal. "Some of the best results were achieved when I got my teenage daughter to stand behind me and talk to them." Canon EOS 300D with 18–55mm lens, set at ISO 200.

" Look for creative ways to add interest. "

beforehand, scout out locations whenever possible, and make sure you have the equipment to cover all eventualities.

When Bi Scott was commissioned by consultancy company Oxera to photograph its directors, her brief was to take a closeup, a torso shot, and a middle-distance shot of each individual against a white background. The plan was that when the images were printed, the company's corporate colors would be dropped into the background or added as a frame in order to "brand" them. She was given a very

small room to work in, but it had two windows at right angles to one another, which allowed her to work in natural light. This was a major advantage, because setting up studio lights and having to meter for different shots would have taken up time, as well as creating a very tight squeeze in a small space.

above ➤ **Jim Gordon wanted to show this husband-and-wife team working in tandem. The seafront offices had large windows, but he also used fill-in flash bounced from the ceiling. Nikon F90X, 70–210mm lens, Kodak Tri-X 400, ¹⁄₁₀₀₀ sec at f/5.6.**

above left ➤ **Photographing people who wear spectacles can be tricky. Scott's solution was to ask her subject to take them off and hold them in her hands. Canon EOS 300D with 18–55mm lens, set at ISO 200.**

12A 13 ➡ 13A

Schools and colleges

Most towns have a commercial photographer who specializes in formal scholastic portraits. The class lineups may change each year, but the requirements remain constant: individual portraits of students, for sale to parents and for use in yearbooks; class group photos; societies and sports teams; and graduation pictures.

This is a difficult area for the newcomer to break into. Many scholastic photographers are well established and have links with local institutions that go back many years. They have invested in specialist large-format equipment, have long experience of organizing shoots, and are able to offer a high-quality printing, mounting, and framing service geared to meeting large volumes of orders.

Nonetheless, there is plenty of scope for less formal, everyday portrait photography. Schools often welcome volunteers with photographic skills, to document after-class activities, plays and concerts, outings, and so on. Many have Web sites where pictures of this sort are posted for the children, and parents, to enjoy.

above ➤ **Christ Church tutor William Thomas at his desk: Bl Scott tried different versions of this shot, with both wide angles and close crops. The wide view worked best, as it placed the subject firmly within his environment and gave a much richer impression of his working life. Canon EOS 5, 28–105mm lens, Fujichrome Sensia.**

left ➤ **Commissioned by Christ Church College, Oxford, UK, to illustrate a fundraising brochure, Scott was asked to capture four of the college choristers crossing the road, to echo the famous cover of the Beatles'** *Abbey Road* **album. However, the traffic was too heavy, so she opted for a narrative shot that included the college in the background, a group of the boys, and choir master Stephen Darlington dressed as a crossing guard. Canon EOS 5, 28–105mm lens, Fujichrome Sensia.**

right ➤ **Post-exam celebrations are a regular sight in university towns, and Scott finds that students are usually happy to have their picture taken. Such occasions provide plenty of scope for humorous shots—but take care to keep your camera dry. Canon EOS 5, 28–105mm lens, Fujichrome Sensia.**

Photographic opportunities

At a more business-oriented level, schools and colleges—especially private ones—are always in need of pictures for Web sites, magazines, and other in-house publications. These may be formal head shots of staff or documentary-style photographs of staff and students engaged in campus activities—studying, socializing, playing sport. School publications include prospectuses and brochures aimed at attracting new students and journals of record for alumni (which often have a fundraising angle). Alumni associations—and especially reunion dinners—are another avenue of opportunity.

In a university town there is always something going on. There are usually plenty of student theater shows in production, all of which require publicity shots for posters and front-of-house material. The same is true of student choirs and orchestras, rock and jazz bands, and solo performers. Then there are public lectures, debating societies, political and volunteer groups, sports clubs, and the party circuit. And, more often than not, there is enough happening in the street to keep the documentary photographer occupied: demonstrations, charity week pranks, or students celebrating after exams.

It's fine to take reportage-style pictures in a public place; however, you should not venture onto school premises or a university campus without permission. Some establishments require photographers to be accredited before working with young people: check beforehand whether this is necessary.

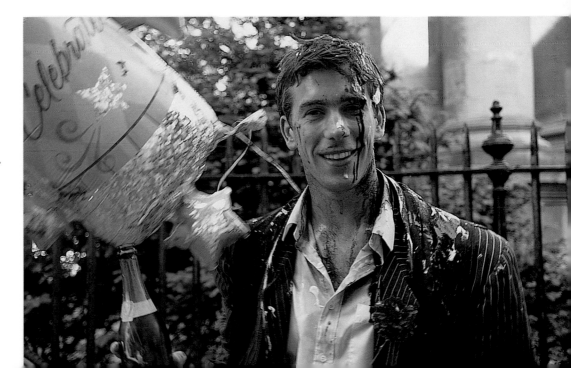

Live performance

When shooting performers onstage, the photographer has very little control over the lighting. It is invariably low, with illumination limited to a few spotlights, and large areas of darkness surrounding the artists. Short of using flash—and killing the atmosphere—he has to make the most of the available light, and frequently has to push his equipment to the limit.

Stage lighting tends to have a strong red or orange cast, which shows up on color film. In theory this can be corrected with filters, but in practice adding filters cuts out too much light. Sometimes you just have to accept the cast as part of the picture. At other times, black and white is a better option—and for some subjects, such as jazz, with its mellow, moody associations, it may suit the subject better, too.

Paul Medley uses ISO 400 black and white film for his jazz pictures, but often pushes it to ISO 800. "You're usually working in very contrasty lighting, and ISO 800 is the furthest I like to go," he explains. "At 1600 there's a lot of grain and you lose a lot of detail—though, of course, that can be okay if it's the effect you want."

right ➤ **Guitarist Pete Oxley was illuminated by a single spotlight directly above his head. Paul Medley chose to exaggerate the high-contrast lighting by including a large area of dark background in the frame. Canon EOS 3, 80mm lens, Ilford Delta 400 rated at ISO 800, ⅓₀ sec at f/2.8.**

Even with the film uprated, a typical shutter speed is ⅛ sec or ¹⁄₃₀ sec. "I always sit down to shoot, as near the front as I can, or sometimes lean against a wall. You should choose one position and stay there if you can. Venues are often crowded and it's no good if you're being jostled," says Medley. "Then it's a question of controlling your breathing so the camera doesn't move when you fire the shutter—a bit like firing a gun."

Anticipating the moment

Of course the performers themselves are moving all the time, so getting a sharp shot requires a degree of anticipation. Medley normally watches a performance for up to 45 minutes before taking any pictures, observing how the musicians move and trying to pick out a characteristic moment when they're still—rather like a pendulum at the limit of its swing, before it starts to move back again.

The next challenge is to get the focus right. Autofocus can sometimes be useful, though not all systems are accurate in dim lighting conditions. "I normally focus on the eyes and then move downward to compose the shot," says Medley. "Sometimes you end up with the instrument in focus instead of the eyes, but that doesn't always matter."

He has recently started experimenting with a digital camera to take color shots at gigs. "It's great for correcting color casts—you can set the white balance for each individual shot. It's also incredibly good at picking up detail in low light. However, if the highlights burn out, there's less you can do to retrieve them than with film."

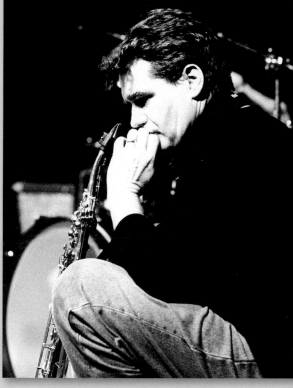

above ➤ **Saxophonist Mark Lockheart caught in a pensive moment. Medley pushes ISO 400 black and white film to ISO 800 to improve his chances of getting a workable shutter speed. Canon EOS 3, 80mm lens, Ilford HP5 rated at ISO 800, ⅛ sec at f/1.8.**

left ➤ **Medley sits as close to the stage as he can and studies the musicians carefully before he starts to shoot pictures. The cymbals and microphone stand provided a frame for this shot of drummer Clark Tracey. Canon EOS 3, 80mm lens, Ilford HP5 rated at ISO 800, ⅛ sec at f/2.8.**

Case study: Michael R. Williams

Inspired by the work of Andy Warhol, Michael R. Williams studied at art college—though not photography, but art and graphic design. It was here that he started taking photographs, using them as a basis for his design work, and he went on to do a degree in the subject.

Now based in London, he's an established photographer with a strong reputation, whose main area of work is music photography. He supplies images to magazines such as *Uncut* in the UK and *DIW* and *Remix* in the US, and promotional shots to music companies and record labels. He also works for business magazines and charities, and publications such as *Die Zeit* in Germany and *Time* magazine. As a sideline, he offers special rates for unsigned bands in need of promotional photographs, and shoots portfolio pictures for actors and models.

When he was starting out, Williams studied the work of other photographers carefully. He admired Anton Corbijn and, when he moved to London, contacted the legendary photographer to arrange a meeting. "It's certainly worth getting real-world feedback on your portfolio," he says. "You may get good grades at college, but that won't necessarily help you to get work later."

One of the best routes into the business, he says, is to work as an assistant. The assistant's role is that of general dogsbody, often for minimal wages. However, the experience is invaluable. "You learn how to organize a shoot and art-direct, and you pick up lots of little tricks and shortcuts," says Williams. "You learn how to get your 'banker' shots: in the professional world, you don't have the luxury of reshooting. Just as

important, assisting helps you build up contacts, and gives you experience of being around bands. You have to be comfortable with people—some performers can be quite difficult to work with."

below ➤ **Williams counts this shot of Cornershop among his favorites. "I only had 30 minutes with the band and I wasn't happy with what I'd shot. I wanted something stronger showing the two lead members, so I moved them apart and shot a few frames." Bronica ETR-Si, 80mm lens, Kodak Tri-X.**

" If you try to copy everyone else, you won't

It's important to establish a style in your pictures that commissioning editors will remember, but your work must also evolve if it is to avoid looking dated. Williams has a signature style right across his portfolio, but he keeps making little changes, trying new films or experimenting with different locations. More importantly, he is constantly trying to visualize his pictures in fresh ways, to keep the work moving forward.

"It's difficult to forge your own style. Just take a look at the vast range of magazine and CD covers out there," he says. "You can discern trends in the visual style that picture editors go for, and recognize the work of certain, well-established photographers. It's important to keep one eye on what's happening in the business, but it's no good just following trends. If you try to copy everyone else, you won't have a style of your own."

above ➤ **This shot of rock band Suede was simple to set up, according to Williams. "I just found a nice street, lined the band up, and shot from a low angle. The backlighting gave it a very distinctive feel." Bronica ETR-Si, 80mm lens, Kodak Portra color print film.**

right ➤ **Having finished a session indoors, Williams led the two members of Zero 7 up onto the roof of their north London recording studio. "I was looking for something I liked personally. It was quite a simple shot, but we tried out different positions, with the two guys looking in different directions." Bronica ETR-Si, 80mm lens, Kodak Portra 400VC.**

have a style of your own. 🟦🟦

In rehearsal

Shooting performers in rehearsal gives the photographer a relaxed environment in which to work and the opportunity to try out different ideas. "You have some freedom of movement, which you don't have with live performance," says Graham Topping, who regularly shoots classical musicians. "You can also use a tripod, which I do 50 percent of the time. Some artists are perfectly happy for you to get up on the stage, but you have to work like a candid or reportage photographer: you must be very quiet and fade into the background completely. I always tell performers they can kick me out if I distract them in any way—but that hasn't happened yet."

below ➤ **Violinist Corina Belcea was sitting close to the front of the stage, so Graham Topping was able to crop in tightly.**

Being onstage means he can get very close to the musicians, and he sometimes uses a 28mm wide-angle. He moves around a lot to get the composition right, but always very slowly, and stands rather than sits while working. For other shots he sets up the camera on a tripod offstage and works with a long zoom, which allows him to focus in tightly on faces and instruments.

The tripod enables him to use slow shutter speeds to portray movement, but the zoom's small maximum aperture and the low lighting conditions mean he has to use an ultra-fast film to get acceptable results. This leads to an increase in graininess, but Topping feels this suits his subjects well. "Grainy black and white is a traditional idiom for jazz and classical session photography, though perhaps color works better for rock," he says. "I prefer black and white, as inevitably there's a lot of background clutter, which shows up more in color."

left ➤ **Cellist Krzysztof Chorzelski was absorbed in the rehearsal and unconscious of the fact he was being photographed. "A long zoom forces you to get the composition right." Canon EOS 30, 75–300mm zoom, Ilford Delta 3200, 1/125 sec at f/4.5.**

right ➤ **"Melvyn Tan is a wildly flamboyant pianist in concert, but in rehearsal is quite inscrutable, so I was looking for ways to add interest to the shot," says Topping. The deep black tones of the piano made printing tricky. Canon EOS 30, 75–300mm zoom, Ilford Delta 3200, 1/125 sec at f/4.5.**

" You must be very quiet and fade into the background completely. "

Candids

Candid photography is one of the most expressive and revealing branches of portraiture. Capturing a person in a spontaneous moment, whether contemplative or exuberant, can say more about their personality than any number of staged pictures. Freed from the constraints of posing for the camera, people are more likely to let their true nature shine through.

There are many situations where candid photography comes into its own. Family portraits, especially pictures of children, are one obvious area. The most cherished pictures in the family album are often those that catch the subject unawares. Weddings and christenings are happy hunting grounds for the candid photographer. Guests tend to be relaxed and the spontaneous interactions between family members provide the photographer with plenty of material.

below ➤ **Weddings provide Bi Scott with plenty of opportunity for candid portraits. Guests are dressed up for the occasion and are usually happy to cooperate with the photographer. Using flash, even outdoors, helps to lift faces and inject sparkle into the eyes. Canon EOS 5, 28–105mm zoom, Kodak Gold 200, on-camera flash.**

" Freed from the constraints of posing for the camera,

Outside the home, opportunities present themselves wherever people are gathered together. Sports events and music festivals, political rallies, street demonstrations, students celebrating graduation, or simply the local downtown shopping area—all provide plenty of expressive, off-guard moments that the photographer can capitalize on.

Spontaneous interactions

Bi Scott shoots a lot of weddings, and candid pictures of guests letting their hair down always form part of her shooting list for the day. She also shoots formal events for the colleges of Oxford University and, amid the pomp and ceremony, these invariably provide a rich vein of behind-the-scenes spontaneity.

She works with lightweight equipment: a 35mm camera with a moderate zoom lens, which helps her to frame shots quickly. She uses a medium-speed color print film, which has plenty of latitude and is therefore tolerant of slight errors in exposure. She frequently doesn't have time to get exposures spot-on when working quickly and grabbing pictures on the hoof, but this inbuilt margin for error allows her to concentrate on catching the moment rather than fiddling with the camera controls. She also often uses a flashgun: even outdoors, this can help to lift faces out of shadow and add a little sparkle to the subject's eyes.

people are more likely to let their true nature shine through. "

Photojournalism

The aim of photojournalism, or reportage, is to tell a story. It has a long and distinguished history, and frequently a hard edge. Photographers such as Don McCullin and James Nachtwey made their names reporting on armed conflicts around the world, while Robert Capa, founder of the influential Magnum agency, was one of many to lose his life in pursuit of the action. Sometimes the image is glamorous: photographers such as William Klein in the 1960s and, more recently, Mario Testino have adopted a reportage style for fashion and celebrity subjects.

The great French photographer Henri Cartier-Bresson raised photojournalism to an art form, coining the idea of the "decisive moment," the point at which all the elements within the frame come together in harmony. Traditionally, black and white has been the preferred medium for reportage: it has a starkness and simplicity that color photography often lacks. However, the demands of newspapers and magazines, and improved printing technology, mean that many photojournalists now shoot exclusively in color.

It's unlikely you will work either in Hollywood or in a war zone, but there are still plenty of outlets for photojournalistic images, including local newspapers, specialist magazines, business and charity publications, and school and community projects. It's good practice to set yourself assignments to build your portfolio, perhaps covering an issue relevant to your local neighborhood, or creating a feature story based on a travel destination.

The photojournalist's kit bag

- 35mm or digital SLR camera
- Spare camera body for backup
- Choice of lenses, or a general-purpose zoom
- Spare film/memory cards
- Spare batteries
- Blower blush and lens cleaning cloth
- Notebook and pencil
- Compact camera

far left ➤ **"This was an unusual take on the family album shot. Because of the age of the van, and the boys' serious expressions, it has quite a timeless feel to it," says Jim Gordon, who snapped his young son and nephew just after a game of soccer. Nikon F50, 28–200mm lens, Ilford XP2, 1/50 sec at f/5.6.**

left ➤ **Celebrity subjects are a mainstay for many photojournalists. Gordon captured top fashion designer Vivienne Westwood leaving a show at the Victoria and Albert Museum in London. Nikon F50 with 28–200mm lens, 1/60 sec at f/4.8, direct flash.**

The 35mm SLR with a standard lens is the classic photojournalist's tool, though a digital SLR will do the job just as well. Using a zoom has the twin advantages of flexibility in framing and reducing the weight of your kit bag. Many professionals carry a compact camera with them wherever they go, tucked in a pocket or the glove compartment of their vehicle. This can be used to make visual notes of locations, and means they will never miss a picture, even if something interesting happens when they are "off duty."

Although your aim is to capture a slice of real life, you should always behave considerately toward the people you photograph and avoid being intrusive or voyeuristic. Ask permission, and if someone doesn't want their picture taken, don't take it. For those who cooperate, it's polite to ask for their name and address and offer to send them a print afterward.

left ➤ **These two men persuaded the London authorities to open up Admiralty Arch in Trafalgar Square as a hostel for young homeless people over the winter. Gordon pictured them in front of the building, using a red filter to bring out detail in the façade and in the clouds behind. Nikon F90X, 28–200mm lens, Ilford XP2, ½₀₀₀ sec at f/5.6.**

Editorial commissions

Many aspiring professionals would like to work for the music press, but it's a tough area to break into. "Getting started is very difficult: there are so many photographers out there competing," says London-based pro Michael R. Williams. "However, magazines can't afford to commission top photographers like Annie Leibovitz or Albert Watson for every issue. There are varying levels of budget. You have to first break into it, and then move on up in small steps. No one becomes a photographer for the top magazines overnight."

Williams, who supplies music magazines on both sides of the Atlantic, shoots most of his pictures on medium-format cameras, using standard lenses. He uses digital only occasionally, for location scouting and snaps. "Like a lot of magazine photographers, I still work on film, because of the quality it gives. For this type of photography, medium-format is the format of choice. I know it's going to change: digital is getting very good, and in some areas is already dominant—news and sport, for example, where you have to get material to the picture desk quickly. With magazines, however, you're not working to such tight deadlines."

Williams previously used Bronica and Hasselblad cameras, which are 6x6cm format, but has recently switched to 6x7cm Mamiyas. The larger format gives extra detail in the image and fits the magazine page better. He prefers color negative film to transparency, favoring Kodak Portra NC and VC emulsions, while Kodak Tri-X is his usual choice for black and white work.

"I like the control you get from a negative," says Williams. "You often have very little time to work in, especially with bigger bands, and negatives are more forgiving if you're half a stop

above ➤ **"You can look at twenty-five walls before you find one that works," says Michael R. Williams. He sometimes scouts out locations, snapping backgrounds for future reference with a compact camera. This shot of Whirlwind Heat, however, was a simple grab shot, taken in a back street near the venue they were playing. Bronica ETR-Si, 80mm lens, Kodak Tri-X, toned print.**

out with the exposure. You can also tweak your prints, holding back some parts or burning others in." When he first started out, he did all his own printing, but now he relies on trusted lab printers.

Maximizing backgrounds

Most of Williams' work is done on location, outdoors and in available light. Backgrounds are important, and he tries to scout them out beforehand. Sometimes he has little control over the location, having to go wherever a band is doing an interview and perhaps only having 10 minutes to shoot. On more relaxed occasions, he'll simply meet the subject, start talking, and take a walk, stopping occasionally to take photographs. "I keep in mind backgrounds that I've spotted previously," he says. "I carry a compact camera in my bag, and take snaps for future reference, with someone standing in that spot if possible."

The amount of time he spends with his subjects varies from five minutes to several hours. Generally he has to work quickly, so he keeps things simple, shooting handheld with the minimum of equipment. "I like to keep it fluid, and a tripod can make things feel too formal," he says. "Occasionally I have an assistant to hold reflectors, but mostly I work on my own. I want to concentrate on the person, to get a certain intensity in the portrait."

above ➤ **For his color work, Williams prefers print film over transparency, as it is more forgiving of exposure errors and can be manipulated at the printing stage. This shot of singer Neil Hannon of The Divine Comedy, commissioned for a magazine interview, was taken on a bridge. It was a gray day, but Williams decided to make a feature of this, instructing his printer to darken the sky by burning it in. Bronica ETR-Si, 80mm lens, Kodak Portra 160VC.**

RVP ▷ 11 RVP ▷ 12

Making your photography work

❝ Post-production is just as important as the capture

8A 9 ⟶ 9A

RVP ▷ 13 RVP ▷ 14

phase, and presentation is the acid test of your skill as a photographer. **,,**

Making your photography work

Processing and printing

You may have taken a stunning set of pictures, with perfect lighting and an inspiring subject, but the work is by no means over once you've pressed the shutter release. The post-production phase is just as important as the capture phase, and presentation is the acid test of your skill as a photographer. If your pictures are badly printed and poorly presented, it undoes all the good work that has gone before.

Most photographers (even professionals) still rely on commercial laboratories to process their color work, both print and transparency. Depending on your budget, you may entrust your films to a specialist professional lab, a high-street mini-lab, or a mail-order processor. Inevitably you get what you pay for, so choose the best service you can afford. Processing services offered by high-street labs and specialist photographic stores are often of a very high standard and should cover most of your needs, at least while you're starting out. Shop around: it may take a while to find a lab you can trust, but when you've found one, stick with it.

Darkroom vs. digital

Black and white always costs more to have processed than color, because of the smaller volumes involved, but in any case photographers often prefer to develop their own. It's relatively straightforward to set up a home darkroom, provided you have a space you can convert. This gives you complete control over your images: you can decide on the size and shape of the print, adjust tone and contrast, retouch flaws,

and create a variety of special effects. Black and white printing is still regarded as a highly skilled process, especially by fine-art photographers. However, for the vast majority, enlargers and chemical trays are now a thing of the past, due to the rise of digital photography. Increasingly, computers are used for every conceivable task, from retouching prints to storing and archiving pictures. Software packages such as Adobe Photoshop make it easy to enhance images before they are printed, and color correction and special effects are now simple to achieve.

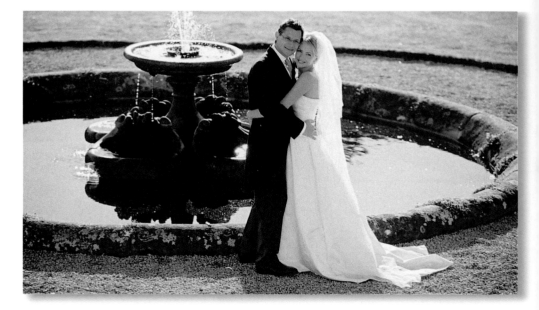

above ➤ **David Fisher shoots all his weddings on color negative film, but scans the pictures to create online wedding albums and to carry out post-production manipulation. If he thinks** a shot might work well in black and white, it's easy to convert it using Photoshop. Nikon F100, 200mm lens, Fujicolor NPH 400.

You don't even need a digital camera. With a relatively inexpensive scanner you can convert traditional prints and negatives to digital files, work on them on your computer, then print them out on an ink-jet printer, or save them on a CD before taking them to a lab for printing. Many photographers combine old technology with new, retaining the special qualities of silver halide film, but taking advantage of the flexibility and convenience of digital enhancement.

above and right ➤ **In this shot, the tight confines of the venue meant that Paul Medley could not capture guitarist John Etheridge without including the stage lights and another performer in the frame. Using Photoshop allowed him to mask out these distractions and clean up the image. Canon EOS 3, 80mm lens, Ilford Delta 400 rated at ISO 800, ⅟₃₀ sec at f/2.8.**

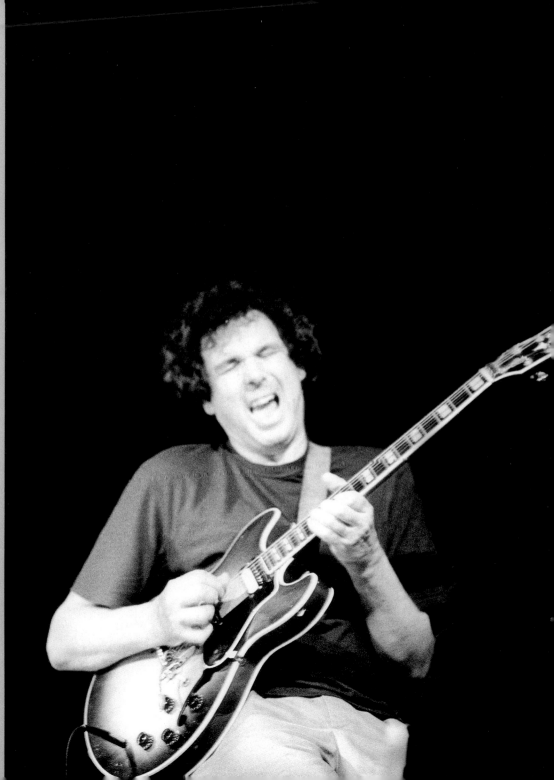

Enhancing the image

There are various ways to tweak an image at the processing stage. Films can be "pushed" or "pulled" (essentially, over- or underdeveloped) to boost or reduce contrast. Color transparency (E6) films can be cross-processed in color negative (C-41) chemicals, to increase contrast and alter colors. A cheap, but effective, way to create a sepia-toned image is to shoot on a chromogenic black and white film, such as Ilford's XP2, and have it processed through a standard color mini-lab.

Black and white printing techniques include dodging and burning. "Dodging" means masking off certain areas of the print during exposure to make them lighter; "burning" is the opposite: giving greater exposure to certain areas to darken them. Special effects such as vignetting and solarization can also be created at the printing stage, and various colored tones and washes can be applied as the print is developed. Finished prints can be "spotted" to disguise blemishes, or prints can be hand-colored to create an appealingly retro look.

Image-manipulation software now means that all this—and more—can be achieved digitally, without the need for a darkroom. One of the most flexible programs, and the closest there is to an industry standard, is Adobe Photoshop, but there are plenty of others on the market. You may even get a basic one as part of the package when you buy a digital camera. Programs like this allow you to work on color images as well as black and white. One of their most basic functions is to remove red-eye from

above ➤ **Graham Topping used his knowledge of design to create this study of piano duo Kathryn Stott and Noriko Ogawa. "Context always affects the way you see an image," says Topping. "For instance, when shooting pianists,** it's almost impossible to get their face and hands together in a single shot." His solution was to shoot two separate sequences of faces and hands, then assemble them in Photoshop, creating borders to differentiate the images.**

❝ There's nothing like getting it right first time. ❞

flash shots, but you can also correct colors, retouch facial flaws, or change backgrounds—but resist the temptation to overcook things.

Digital technology is sometimes criticized on the grounds that photographers treat image-manipulation software as a safety net, in the belief that any image, however sloppily thrown together, can be rescued at the post-production stage. There is no excuse for laziness. There's nothing like getting it right first time, and a good digital picture (like any other) is one that is tightly composed and correctly exposed, with a minimal need for manipulation afterward.

above and right ➤ **Photoshop permits composite images to be created much more easily than in the traditional darkroom. David Fisher made this image for a theater poster, using high-key lighting to isolate the subject from the plain paper background. He then scanned the negatives into an Apple Mac computer and, using Photoshop, digitally matched up half of one image with half of another. "It's a very simple process—essentially just cutting and pasting," explains Fisher. "You crop each file in half, then double the canvas size in one direction so that half of it is plain white. You then take the other cropped image and drop it into place, taking care to align the two halves."**

Editing and archiving

You should always be editing your images, both while shooting and in post-production. Even if your work is technically perfect, your shots will lack interest if they all look the same. Instead, mix them up, with different crops and framings: wide shots, closeups, different eye levels, shots with the camera tilted at an angle. If you don't get the crop right in-camera, it can often be tightened up at the printing stage. Weak shots and outtakes should be weeded out before you deliver the pictures to the client.

The order in which images are presented is important. The pace should change from shot to shot, to maintain interest and tell a story. The classic example is the wedding album. This should include all the key moments of the day, but there's no need to present every shot strictly in the order it was taken. You could create pages containing a cross-section of bride-and-groom pictures taken at different moments, and others grouping candids of the guests. Look for pictures that work well together, and construct sequences that illustrate a particular theme. Vary the presentation: perhaps a grid of nine small shots on one page, with one large shot opposite. Try mixing color shots with black and white, and don't forget detail shots that add to the overall picture.

right ➤ **Stefanie Herzer was asked to recreate a montage shot spotted in a shop window. She used Photoshop to crop and assemble the images. "The tricky part was to get good alignment, with each shot parallel to the focal plane," says Herzer. Canon EOS IDS, 70–200mm IS lens, studio lighting.**

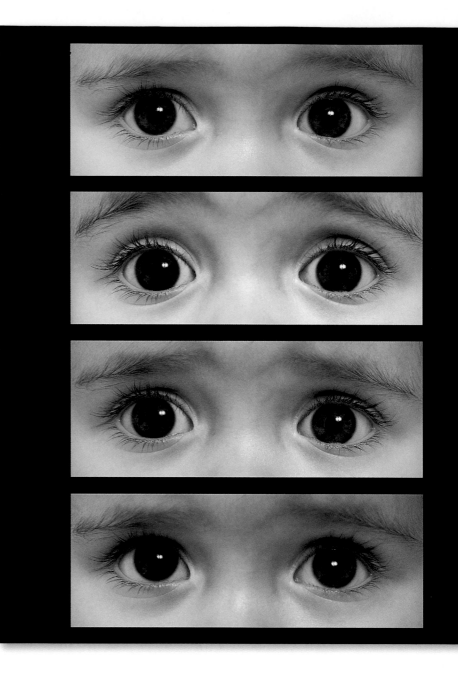

15A 16 ➡ 16A

Sequences of images

In other contexts, sequences of images can be montaged together to create new perspectives on a subject. Graham Topping became increasingly interested in sequences during a long-term project to photograph classical musicians. "Originally, it came from using a tripod," he explains. "You have to keep quiet in rehearsals, and once you've positioned the tripod, you're likely to take three or four shots before moving on. The background stays the same in each shot, but the subject's movement from frame to frame creates a kind of cinematic narrative." Again, there's no need for sequences to be chronological: you can tweak reality by

arranging images in the order they work best. "It stretches the definition of a portrait," says Topping. "What you end up with is an interpretation of the person and their involvement in the music."

Every photographer needs a secure system for storing their pictures. Negatives and transparencies should be filed in protective sleeves, while prints can be kept in folders or boxes. All should be stored in cool, dark conditions, safe from heat and humidity. Electronic images should be organized into folders and, ideally, backed up on CDs or an external hard drive. Everything should be clearly labeled, and you should develop a cataloging

system that will allow you to retrieve images instantly. Never throw anything away: clients can come back for reprints long after the pictures were originally taken.

below ➤ **These shots of cellist Jonathon Cohen were taken just a few moments apart. Graham Topping used three frames from the sequence to create a single exhibition print. Canon EOS 30, 75–300mm zoom, handheld, Ilford Delta 3200, $\frac{1}{125}$ sec at f/4.5.**

Case study: **David Fisher**

David Fisher runs a thriving portrait, theater, and wedding photography business, based in Oxford, UK. His interest in photography began while at high school in Townsville, Australia. He did a two-year diploma in the subject at university, followed by six months working in a camera shop, before landing a job as an assistant in a studio where he'd done work experience. He spent two years there learning the ropes before heading to the UK, in search of his own style.

He took on a variety of jobs and, while working nights at a cinema, spent his days doing freelance assisting jobs for different photographers. Building on this, he started his own photography business, working from home. His early commissions were mostly portraits, but he also did commercial and architectural work, including a contract to photograph cinemas. In addition, he began teaching evening courses and did some Web-site design.

The next move came when a picture framer who had previously employed him expanded into new premises and offered him the basement space as a studio. Renting a studio meant that Fisher's expenses sky-rocketed, but

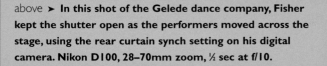

above ➤ **In this shot of the Gelede dance company, Fisher kept the shutter open as the performers moved across the stage, using the rear curtain synch setting on his digital camera. Nikon D100, 28–70mm zoom, ½ sec at f/10.**

his business was also beginning to grow. After a few years he employed a full-time assistant, mainly to do Photoshop work and maintain his Web site, but also to be trained up to help out on the photographic side.

Fisher's advice for the beginner is thoroughly practical. "You can become a photographer from day one," he says. "The way to get your very first commission is to approach someone and ask them if you can take their portrait. In return, give them a copy of their favorite picture from the session. If they want any extra prints, you can sell them for a nominal fee, which might just cover the cost of your materials. Once you've done that, take your prints and show them to someone else, and do it all over again. Before you know it, people will start talking and asking you to do little jobs—shooting a wedding, photographing the family pet, and so on."

Resist the temptation to rush out and buy a lot of expensive equipment. According to Fisher, the trick is to expand only as fast as you get money in. His advice is to use the first $10 you earn to buy more materials. With the next $20, spend $10 on materials and save $10 toward your next piece of equipment. Put a little more aside each time, and try not to spend money before you actually make it.

"Don't be afraid of the big 'P' word," says Fisher. "Be frank: tell people you're not a professional, but will take their picture for a small fee. Read books, study the work of other photographers, do courses. Above all, approach people and get your name around. The best way to build your business is by word of mouth."

left ➤ **This was a publicity shot for a play about the novelist Charles Dickens. Fisher lit the actor using a softbox to the left, with a honeycomb spotlight behind him to create a shadow and pick out the books. Ebony SV45TE field camera, 150mm lens, Polaroid Type 55 Positive/Negative film.**

below ➤ **For this personal project Fisher used a field camera on a sturdy tripod, tilted, and at a high angle to exaggerate the perspective. "It wasn't a spontaneous shot—it was entirely set up." Ebony SV45TE field camera, 150mm lens and tripod, Ilford HP5 film, ½ sec at f/5.6.**

" Don't be afraid of the big 'P' word. "

Marketing and Web sites

The best possible recommendation a photographer can have is word of mouth. However, it's rare that business simply comes in through the door: you have to get out there and market yourself. There are several ways to do this. You can advertise in the local press, or pay to take out a display ad in local telephone or business directories. You can put up posters in local libraries, community centers, or arts venues. Many photographers have postcards printed showing samples of their work, which double up as business cards. It's quite easy to create publicity material of this sort on your home computer and to tailor it to your different strengths. Always make sure that you include your contact details, especially your phone number and e-mail address.

Perhaps the best marketing tool a photographer can have is a well-designed Web site. This acts as a shop window for your work: it allows potential customers to assess your work quickly and decide whether your style of photography is right for them. There's no shortage of professional Web designers who can set up a site for you, quickly and at a reasonable cost, and once the site is up and running, it's inexpensive to maintain. Alternatively, you can join a Web hosting service: these are special-interest sites that maintain pages in return for a small subscription. Check out the ads in photography and computer magazines, or try searching the Web for them. If you have a modicum of technical skill, it's quite straightforward to construct your own site, using HTML programming.

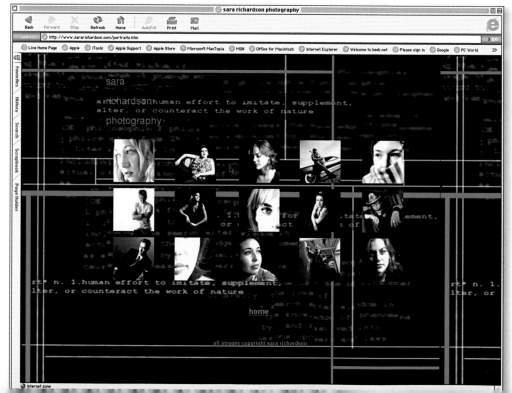

Keep it simple

The key words when it comes to Web site design are "speed" and "simplicity." Users want to navigate a site with the minimum of fuss, so be sure to keep the design clean and uncluttered. Limit yourself to a small number of pages, with a simple menu and clear click-through links to each page, and check periodically that all the links are working as they should. Make sure that you include a page with your full contact details, including a direct e-mail link. If people don't know where to find you, then you won't win their custom.

Sites generally have more impact if they contain just a few of your strongest images, rather than your entire portfolio. However, if you have different areas of specialism, it's fine to have a page for each. You can update the site regularly with samples of your latest work, to keep it fresh. It's standard practice to display pictures as thumbnail images; the user clicks on the thumbnail to see an enlargement, if required. Keep image files relatively small and low-resolution: on a dial-up connection, large files take a long time to download, and this is a sure way to lose the attention of the visitor. The same goes for fancy extras. Flash presentations may be impressive, but they are often slow to load and so another turn-off. Avoid the temptation to overcomplicate things.

Nowadays nearly all photographers who are serious about their subject have their own Web site. For most, the Web functions as a cost-effective publicity tool, but many professionals have gone a step further and used their Web sites to set up online ordering and payment schemes that their customers can access directly.

left, below left, and right ➤ **Sara Richardson designed her Web site herself, to function as an online portfolio. The title page of the site leads to a home page, followed by galleries of thumbnail images. Clicking on an individual thumbnail enlarges the image.**

below ➤ **Stefan Hester favors a slideshow approach, in which a sequence of pictures within each subsection of his site is viewed by clicking the "Forward" and "Back" arrows beneath the image.**

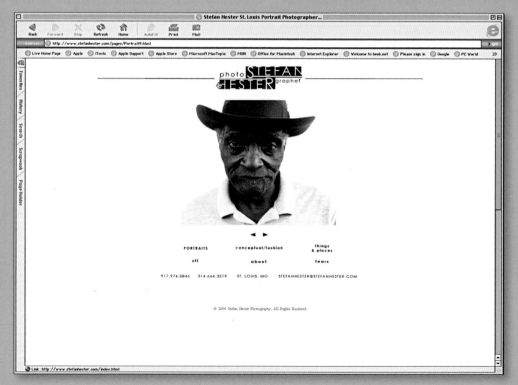

6A 7 ➡ 7A

Spreading the word

David Fisher treats his Web site as an online portfolio and, as such, an important adjunct to his business. "For the portrait photographer, who offers a very personal service, Web sites are ideal," he says. "A well-presented and well-maintained site can be an important source of business. There's no better way of getting people to choose than online: they can browse different sites and find a style of photography they like, without any obligation. Nowadays many people choose this way to find a portrait photographer." In Fisher's experience, customers tend first to scour their local phone directories, to pick out photographers who have their own Web sites. "Initially, there are three potential barriers," he says. "First, if you don't have a Web site at all, people will discount you straight away. The same is true if your site doesn't work. Likewise, if it's ineffective or badly maintained, with poor design and broken links—and so many are. If you can get past these three hurdles, you have a good chance of getting business."

left, above, and right ➤ **David Fisher's Web site is carefully constructed to be informative, visually appealing, and easy to navigate. Clicking on the links at the top of the home page takes the visitor to separate gallery pages for Fisher's portrait, wedding, and theater photography. Clicking on the thumbnail images brings up a slideshow window, in which enlargements are shown as the viewer uses the "Forward" and "Back" buttons. The "Info" page is an essential part of the Web site, containing information on pricing, business hours, how to get to the studio, FAQs, and the all-important contact details.**

" There's no better way of getting

The fact that customers can see pictures online—and other information such as pricing—acts as a filter and cuts out time-wasters. "People won't contact you unless they're interested in what you're offering," says Fisher. "I'm in the minority of photographers who put prices on their site, or at least an indication of them. I prefer to be upfront, so that if people think it costs too much, they won't waste either their time or mine."

The figures Fisher puts on the site are his base prices—effectively the minimum order. Naturally he hopes that, if customers like the results, they will order additional prints. "You don't want to scare people off if they haven't seen the full product. It puts the onus on you as the photographer to do a good job, so that when they see the pictures they'll want to buy more. Some photographers use high-pressure sales techniques, such as payment plans, to get people in through the door, but I don't believe in that."

As an optional extra, Fisher can set up a Web gallery on his site so that clients' friends and family can view pictures and order prints online. Users can access the page using their own password, or it can be left open to all. Customers select images using thumbnails and pay using a shopping cart and secure payment system. The service is particularly popular with wedding clients, but Fisher also uses it when he covers university balls. On the night of a ball he shoots everyone he can, but takes no money—he simply collects the e-mail addresses of potential customers and then directs them to the Web gallery once it is set up.

"The reality of the Web site is that it's not a huge money-spinner, but it is a great way of marketing the business," says Fisher. "It spreads the word. For instance, if a wedding guest browsing a gallery is impressed by what they see, it could well lead to your next wedding booking. Web sites just need to be logical and give people the information they want. If you can do that with a little style, so much the better. Remember, pictures are what make a Web site."

people to choose than online." „

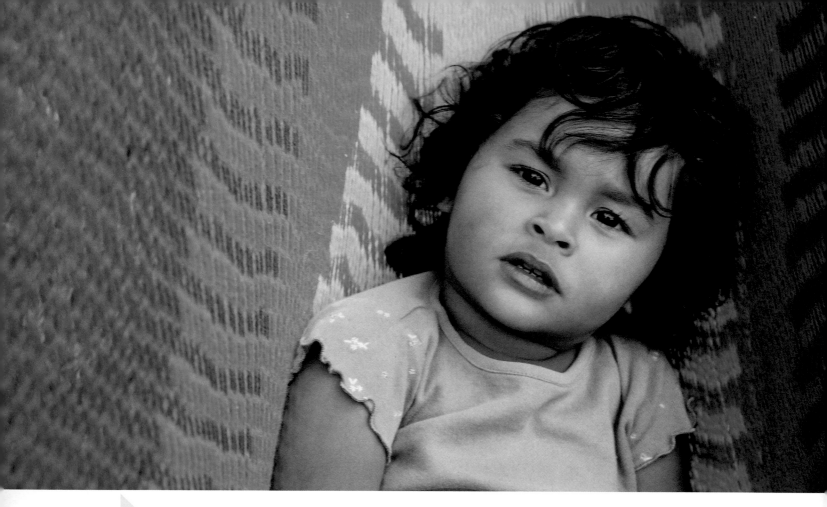

Selling your work

Most portrait work is social photography of one sort or another: weddings, engagements, new babies, graduation pictures, and so on. The bulk of this work is commissioned by families, who want pictures either for themselves or as gifts for friends and relatives. It's vital to establish a good rapport with your customers. Listen to what they want, and ask plenty of questions yourself.

You must aim to produce the type of picture they want, rather than anything you might prefer personally. You should also offer them as much choice as possible. In the past, the only service on offer was the traditional studio portrait, but now a lot of photographers—and their clients—prefer to work on location. Some social photographers now work entirely on location, dispensing with the need for a studio altogether.

There should also be variety within the session itself. Try out different locations and clothing. Shoot in different styles: alternate between long shots and closeups, or switch from color to black and white, or from 35mm to medium-format. Remember that different types of picture may appeal to different family members. The wider the choice, the greater the chances of sales.

Pricing yourself

It's very difficult, when you start getting customers, to know how much to charge them. The only rule on pricing is that there is no such thing as a "correct" fee: different photographers charge different prices, depending on their expertise and the level of service they offer. Start out by finding out what other photographers are charging locally, and establish exactly what is included. In most cases, at least one print is offered as part of the sitting fee, but reprints and enlargements invariably cost extra.

Once you've decided on a scale of fees, make sure each customer understands it before the session is booked. Communicate clearly what is included in the price, and what is extra, to avoid misunderstandings later. Be prepared for scrutiny from their side, and have sample work (an album or portfolio) ready to show them.

Think too about additional services you could offer. Some clients like to have their pictures presented on a CD, for reference. If you're handy with Photoshop, you can provide a retouching service, as many people have old family photographs they would love to have restored. Discuss presentation and framing, but be honest about what type of enlargement will work best, and don't simply encourage clients to buy the biggest and most expensive. If you can't offer these services yourself, track down someone locally you can trust, and refer people to them.

David Fisher shares his premises with a framing business upstairs from his studio. He encourages his customers to buy frames, but never insists. "I'm not the classic studio photographer who sells the frame as part of the package," he says. "However, I do make sure every print goes out in a little mount. The framing business is notionally completely separate, but we share the costs of the space and like to see ourselves as one big business, offering a complete service."

far left ➤ **This was a dull day, but Bi Scott's shot was enlivened by the bright colors of the hammock. Canon EOS 5, 28–105mm lens, Fujicolor 200 print film.**

left ➤ **Jim Gordon arranged his subjects against a plain white wall and bounced a burst of flash from the ceiling. Nikon F50, 28–200mm lens, Ilford XP2, $\frac{1}{250}$ sec at f/5.6.**

below ➤ **Stephen Smith shot this on a medium-format camera with a digital back and converted it to black and white.**

Exploring markets

Passport pictures provide bread-and-butter-work, but pay far less than a proper portrait session. "You just about break even," says David Fisher. "However, they can prove a great opportunity to sell yourself to future clients—and, after all, it's better to be shooting a passport picture and getting paid for it than sitting at your desk trying to think up ways to market yourself." Many national agencies have strict rules on passport pictures—the background should be plain, and the subject should be looking directly at the camera with a neutral expression, and not wearing a hat or sunglasses, for example.

Award ceremonies are held regularly both by big companies and by schools and colleges. With winners trooping up on stage one after another to shake the hand of the chairman or principal, there is limited scope for creativity. You have to work quickly, usually with on-camera flash and in a confined space. However, such ceremonies can be lucrative in terms of print sales—there will be a lot of individuals interested in their own moment of triumph. This type of image is also widely used by in-house publications, local newspapers, and specialist magazines. In some countries, **citizenship ceremonies** are well established, usually taking place at the local register office or town hall.

right ➤ **For this publicity shot of a modern-dress Shakespeare play, David Fisher used a 35mm SLR with a long lens. A reflector directed the soft afternoon sunlight back onto the faces. Nikon F100, 200mm lens, Ilford Delta 400, ½₅₀ sec at f/4.**

3A 4 ➤ 4A

Performers, such as actors, models, and musicians, need images for their portfolios, and theaters and music venues require images for publicity and front-of-house material. It's customary to shoot theater pictures during the production's dress rehearsal, while portfolio pictures can be shot either in the studio or on location, in a photojournalistic style. Musicians always need images for CD covers, while authors require portraits for the dust jackets of their books.

Fine art prints offer a decent source of income for some photographers, either through a personal Web site or via a gallery. The biggest success usually comes if you can sell work to a greetings card or poster company. Some images continue to sell year after year, even though tastes and styles change. But competition in this market is fierce, and only a few strike it lucky.

 Travel photography offers few opportunities for direct picture sales, but travel images are often used editorially and by picture libraries. Luxury cruise ships offer a particular opportunity for the adventurous, because most carry at least one on-board photographer to capture the guests having fun during the voyage. This is exceptionally hard work and could scarcely be described as creative but, for the young and ambitious, it offers an excellent training ground and a chance to see the world.

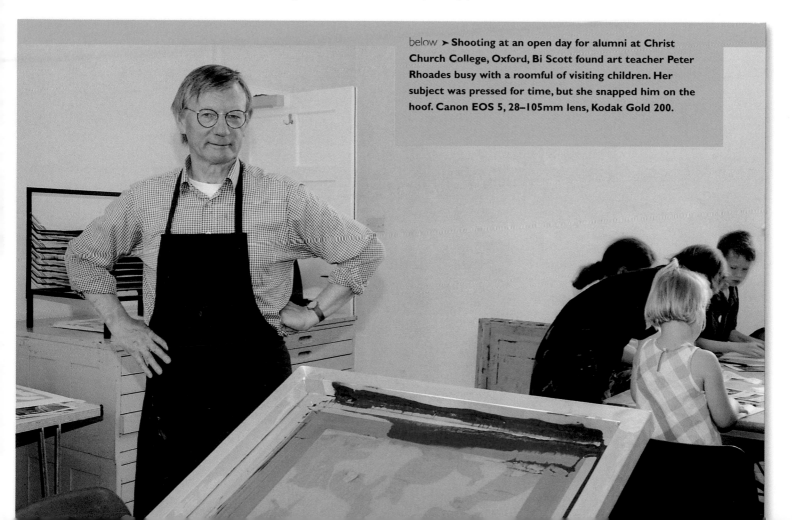

below ➤ **Shooting at an open day for alumni at Christ Church College, Oxford, Bi Scott found art teacher Peter Rhoades busy with a roomful of visiting children. Her subject was pressed for time, but she snapped him on the hoof. Canon EOS 5, 28–105mm lens, Kodak Gold 200.**

Editorial sales

Specialist magazines are a good place to start. Many hobby publications—covering everything from drag racing to quilt making—carry pictures of association meetings, prize-givings, and people in the news. The same goes for business and professional publications. Try putting together picture stories for publications of this sort, and keep tearsheets of any published work for your portfolio. Clubs and associations (and companies of all sizes) frequently require pictures for press and public relations use.

 Local newspapers are always hungry for pictures and, though most have staff photographers, there's usually scope for freelancers. Look out for events happening locally, especially if they involve famous faces. For example, you can often find well-known people doing book signings, especially if you live or work in a big city. Theater productions, concerts, and festivals also offer plenty of possibilities.

above right ➤ **Bi Scott pictured this anti-war protester at a rally in London. This type of reportage-style shot is likely to appeal to newspapers and magazines, especially if you include captions explaining the background to the story. Canon EOS 5, 28–105mm lens, Kodak Gold 200.**

right ➤ **Famous faces always attract interest. Scott pictured opera star Placido Domingo at a garden party when he received an honorary degree from Oxford University. College newsletters and local newspapers would be willing outlets for this type of shot. Canon EOS 5, 28–105mm lens, Kodak Gold 200.**

Getting permission

You need consent from your subject if a picture is to be used for a commercial purpose or supplied to a picture library, regardless of whether the person is famous or not (this doesn't apply to news images). You should get your subjects to sign a model release form, which confirms your right to use the image. These can be obtained from many of the member organizations listed in the Appendix (see page 126). It's always a good idea to do this at the time of the session, to avoid having to track down the person later on.

far right ➤ **Poet Nicholas Swingler asked me to shoot an author's portrait for the back cover of his new book. By this point in the session, the daylight from the window was fading, so an ordinary table lamp, placed to the right of the camera, was used as a fill. This image wasn't selected for the book, but it was later used in a newspaper article about his work. Nikon F90X, 28–200mm lens, handheld, Agfa Scala 200 black and white transparency film, 1/30 sec at f/3.5.**

7A 8 ➤ 8A

Picture libraries operate by marketing photographers' work to clients such as newspapers and magazines, advertising agencies, and publishers of books and electronic media. They split the fees they receive with the photographer—typically 50:50, but with variations either way. In theory, you simply sit back and wait for your paycheck. However, picture libraries are not an ideal outlet, as much portrait work is too personal to be used for stock. Libraries do carry generic shots of smiling children, dynamic business people, and glowing senior citizens, but many of these are posed by models. Technical standards are very high, and most libraries insist on a sizable minimum submission. Most also retain pictures for a number of years to give them a chance to sell, and during this time you won't be able to use them elsewhere. It's usually a better idea to maintain your own archive of images, presented via a Web site.

Exhibitions

Staging an exhibition requires a high degree of organization and a sizable financial outlay, but it can be incredibly satisfying to see your work on display. It can also be rewarding in terms of picture sales and future commissions, though there is never any guarantee you will recoup your costs.

Graham Topping spent a year photographing musicians in rehearsal at a local concert hall before he had enough images to stage a show. The venue had its own exhibition space extending through the foyer, which was perfect in terms of reaching his target audience. He shot all the pictures on black and white negative film, and scanned them before cleaning them up in Photoshop. He concentrated on achieving good

tonal contrast and saturation, and removing dust spots, but otherwise did very little image manipulation. He then ordered giclée prints on archival ink-jet paper, guaranteed to last 75 years before fading, from a local lab.

The most expensive part of the process was framing. Topping had 34 images to display, so he bought a batch of natural wood frames and borrowed others. A vital accessory was a bottle of glass-cleaning detergent for removing finger marks. He mounted the images and printed his own labels, using offcuts from the mounts for backing board. "You have to decide how much information to include in the labels," says Topping. "I decided to state the work each musician was playing. People have very strong associations with particular pieces of music, and I thought this might widen the appeal to potential buyers."

Publicizing the event

He decided on the title "Work/Play" for the show and used this as branding on all publicity material and on signposts within the venue. He designed all the materials himself, creating posters on an ink-jet printer and ordering 1,500 postcards to act as flyers. Of these, 500 were distributed by the venue along with its regular mailings.

"Consistent typography and good design lend coherence to a project," says Topping. "One lesson I learned was to leave plenty of time for the printers—after various mishaps, the flyers eventually arrived four days after the exhibition opened. It's important to shop around to find a good printer."

Topping created a visitor book to enable people to leave their comments, as he couldn't be in attendance all the time. He also made an

order book, quoting prices for both unmounted and framed prints, and asking buyers to leave an e-mail address so that arrangements could be made for delivery. Health and safety was another concern—you need to make a clear agreement with your venue about supervision, and check issues such as insurance liability.

"I didn't really think of it as a selling exhibition—the real point was to get my work seen," concludes Topping. "It was an opportunity to present a coherent sense of my work, focused on a very specific subject. I'd like to tour it to other venues—but I hope it will involve less work next time around."

right ➤ **Publicity is essential for any exhibition. "You need to choose publicity images carefully, as commercial printers often have difficulty handling contrast and you may lose a lot of detail," says Graham Topping. "Go for a safe picture, with lots of latitude."**

below ➤ **Topping created this multiple print of cellist Steven Isserlis in an attempt to convey the subject's animation onstage. He cropped his prints extremely tightly, using less than one-tenth of the total picture area. "Musicians tend to prefer rehearsal images to the publicity shots created by their record companies. When they're caught unawares and unobserved, it's much more intimate." Canon EOS 30, 75–300mm lens, Ilford Delta 3200.**

Portfolios

Every photographer should have a portfolio. It acts as a shop window to potential clients, demonstrating your skills and the quality of your work. Showing your portfolio is a make-or-break moment—if it's poorly presented or the images are humdrum, you've probably lost the interest of that client, and a potential sale.

Select only your best prints for inclusion—a handful of striking images will make a far better impression than a large number of mediocre ones. Don't worry if the selection looks thin to begin with—you can keep adding to it as your style evolves and a body of work takes shape. If you have had any pictures published, include tearsheets from the relevant newspaper or magazine. Don't bother to include your college certificates—it's practical results that clients want to see. Many photographers have their own Web sites, but these should complement (rather than replace) a physical portfolio of work.

Portfolios come in many shapes and sizes. Popular types include folders with clear plastic sleeves, in various sizes such as 12x16in or letter-sized (A4), into which prints or tearsheets can be inserted. A stylish alternative is the box-type portfolio, designed to hold a stack of mounted prints.

right ➤ **Guitar legend Johnny Marr. Michael R. Williams likes to keep his portrait sessions informal and fluid. Often he has very little time to work with his subjects, especially the bigger names in the music business. Bronica ETR-Si, 80mm lens, Kodak Tri-X.**

" Editors won't think about commissioning you

"You have to have a strong portfolio to show to art editors; it's the only way of getting your work known," says Williams. "When picture editors on magazines have pages to fill, they don't go through the phone book—they have a list of people they use, according to budget. Everyone knows what the big photographers can do, but magazines can't always afford them. However, editors won't think about commissioning *you* until they've seen a body of your work."

A Web site is a useful extension to a portfolio, says Williams. "What people put on their sites varies widely—some have a vast selection of work, others just ten images or so. It's very important to tailor it to your market. For me, a Web site is a very useful way to show work to clients overseas, without actually having to travel to see them. They may still want to see your print portfolio, but you can send it out to them once they have an idea of your work and whether they like it."

above ➤ **Williams shot US rockers Ex Models on an industrial estate in east London. It was a bright sunny day and he only had fast ISO 400 film. However, he pushed the film a stop in processing, to boost the contrast further. Bronica ETR-Si, 80mm lens, Kodak Portra 400VC.**

right ➤ **British band Spearmint, captured on a dark evening in Shepherd's Bush, west London. Bronica ETR-Si, 80mm lens, Kodak Tri-X.**

Getting your work seen

For the editorial photographer in particular, a portfolio is essential: you can't get work without one. Selling pictures to the press is a different proposition from setting up as a wedding or family portrait photographer. According to Michael R. Williams, your work might be technically perfect, but you won't get anywhere without networking skills and the tenacity to build contacts with busy editorial departments.

until they've seen a body of your work. "

Courses and qualifications

You should always be looking for ways to improve your photography. Don't fall into the trap of thinking you need the most expensive kit to make it as a photographer. "Top-of-the-range professional cameras may have a few extra features and tougher bodies to withstand knocks, but models lower down the range usually offer just the same in terms of control and image quality," says Paul Medley. "Choose your camera according to your needs, not because you want to put the word 'professional' after your name."

Far more important is an enquiring mind and a willingness to keep practicing and experimenting with new techniques. Consider taking a course, either full- or part-time at college, or one of the many correspondence courses advertised in magazines or on the Web. Most local education authorities run evening classes in photography, and camera clubs offer a variety of workshops and demonstrations.

"Doing a college course is a good entry point," says David Fisher. "Courses give you a certain amount of credibility, and the chance to build up a portfolio, which could help you to get pro work later. Another advantage is that they give you an opportunity to use equipment that you wouldn't otherwise get hold of."

If you're serious about photography as a career, one of the best ways in is to work as an assistant to an established pro. Competition for such positions is fierce, so it's worth considering other options too, such as working in a camera shop or in a processing lab as a darkroom technician. This gives you valuable hands-on experience, and access to equipment and ideas.

left ➤ **Sara Richardson shot this with her portfolio in mind. "Michelle had an interesting look and I wanted to capture some of her edge," she says. Hasselblad 503CM, 80mm lens, Kodak Tmax 400 film rated at ISO 320, Profoto studio flash.**

below ➤ **Jim Gordon, a Licentiate of the BPPA, pictured his son Alfie on the beach, as 250,000 people gathered for an outdoor concert by top DJ Fatboy Slim. He used an orange filter to boost contrast and bring out detail in the clouds. Nikon F90X, 28–200mm lens, Kodak Tri-X 400, $1/1500$ sec at f/5.6.**

It should also give you a realistic idea of what the industry entails and whether it's really for you.

There are many organizations that photographers can join. Some are industry associations reserved for qualified professionals; others are open to anyone who pays the membership fee. "Having the crest of a professional organization on your Web site tends to reassure customers that you're good at what you do—though in reality it's no guarantee of quality," says Fisher. The other main advantage, according to Fisher, is the sense of connection it gives you. "You can meet other portrait photographers, go to seminars, and keep up to date with new products and styles—it stops you getting stale."

Even the most experienced pro is engaged in a constant learning process, as styles change and new equipment and technologies are introduced. Says Jim Gordon, "The best possible advice I can give is not to be scared of making mistakes, study technique and other people's photography, read books, use plenty of film to develop your skills, and—above all—experiment. Rules are made to be broken. Be bold, and enjoy your photography."

" Rules are made to be broken. Be bold, and enjoy your photography. "

RVP ▷ 11 RVP ▷ 12

Appendix

❝ Study technique and other people's photography,

RVP ▷ 13 RVP ▷ 14

use plenty of film to develop your skills, and—above all—experiment. **"**

Contacts

David Fisher is a portrait, wedding, and theater photographer based in Oxford, UK. He strives to take portraits that reflect the personality and style of the subject, whether in the studio, at the client's home, or on location. He has built a large portfolio of theater clients, shooting promotional and poster images and front-of-house material. He has also accumulated a body of personal, fine art black and white work.
David Fisher Photography, The Oxford Framing Gallery, 67 London Road, Oxford OX3 7RD, UK
Tel: *+44 (0)1865 764465*
Web: *www.davidfisherphotography.co.uk*

Jim Gordon works largely in mono. Based in Brighton, UK, he undertakes all types of portrait work, both formal and informal, including children and family, head shots for actors and performers, corporate portraits, publicity material, and commercial photography. His work has been published in newspapers and magazines, and on the covers of music CDs. He also works for agencies in London and south-east England.
Web: *www.jimgordonphotography.com*

Stefanie Herzer is based in San Francisco. She turned professional a few years ago, and now shoots a wide range of subjects, including children, weddings, and environmental family portraits. She works entirely digitally, and offers tuition in Photoshop techniques to other professional photographers. Her pictures of musicians have appeared on the covers of books and CDs, and her work (mostly natural light portraits) is published by leading photographic magazines.
Stefanie Herzer Photography—Powered by Passion
Web: *www.natural-light.org*

Stefan Hester received a BFA in Media Communications from Webster University, Missouri, in 2000. He worked as an assistant to editorial portrait photographer Gregory Heisler and as a freelance assistant to Mark Seliger, Evan Kafka, and Michael Lavine. Today he is an emerging photographer shooting for a variety of editorial and advertising clients. He lives in St. Louis, Missouri.
Tel: *+1 (917) 974-0846*
Web: *www.stefanhester.com*

Paul Medley took up photography while working as a lecturer in English literature in Finland. He trained in Finland and the UK and now works as a freelance photographer, based in Oxford. His work has been published internationally and is frequently used by the classical and jazz music industry. Further work can be seen on his Web site.
Paul Medley Photography and Design, 28 Fairacres Road, Oxford OX4 1TF, UK
Tel: *+44 (0)1865 723316*
E-mail: *info@paulmedley.co.uk*
Web: *www.paulmedley.co.uk*

Sara Richardson graduated in 2002 from Brooks Institute of Photography in Santa Barbara, California with a Bachelor's Degree in professional photography. She spent most of 2003 in London, working as an assistant to music and portrait photographer Michael R. Williams, learning all aspects of the business. In late 2003 she returned to California and now works as a portrait photographer in Los Angeles.
Sara Richardson Photography, 7551 Rubio Ave., Van Nuys, CA 91406, USA
Tel: *+1 818-571-2481*
Web: *www.sararichardson.com*

Stephen Smith, LRPS, is based in Newbury, Berkshire, UK. He specializes in all kinds of studio and portrait photography, including children and pets. He also shoots wildlife.
Tel: *+44 (0)1488 608716*
E-mail: *info@stephensmithphotography.co.uk*
Web: *www. stephensmithphotography.co.uk*

Graham Topping is a journalist with a specialism in classical music, and has been a freelance photographer for 15 years. He has a large picture library relating to his home town of Oxford, where he also works to commission. He has particular interests in church architecture and interiors, and in landscape and travel, as well as in photographing classical musicians. His photographs have appeared in magazines ranging from *BBC History* to *Country Living*.
E-mail: *Graham@toppingg.fsnet.co.uk*

Michael R. Williams is a London-based photographer specializing in creative portrait photography for editorial and promotional use. His main area of work is music photography, supplying images to magazines such as *Uncut*, *DIW*, and *Remix*. He also supplies promotional shots to music companies and record labels, shoots promotional photographs for bands, and takes portfolio pictures for actors and models. In addition, he works for business magazines and charities, as well as publications such as *Die Zeit* and *Time* magazine.
Michael R. Williams Photography, London, UK
E-mail: *info@michaelwilliams.co.uk*
Web: *www.michaelwilliams.co.uk*

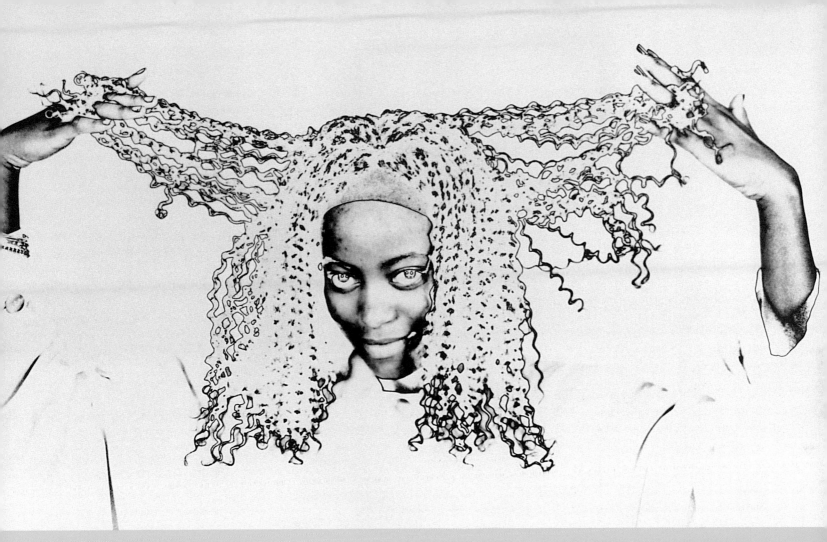

Bi Scott is both a professional photographer (weddings, prospectuses, and portraits) and a practicing linguist (lecturing on Chinese linguistics and on language and diplomacy). The common denominator is a fascination with the power of language (verbal and visual) to shape the way we see the world. In her personal photography she likes to play with double-takes and metamorphosis.
E-mail: *contact@biscott.co.uk*
Web: *www.biscott.co.uk*

above ➤ **Solarization involves exposing the printing paper briefly to light during the developing process, which partially reverses the tones, burns out detail, and creates areas of high contrast. The overexposure has to be carefully controlled to avoid the image turning completely black, and involves a lot of trial and error. Bi Scott created a whole series of solarized portraits, which she staged as an exhibition entitled "Against Portraits."**

Sources of further information

American Society of Media Photographers (ASMP): a member society for commercial photographers. Strong educational content, with a section for assistants. *www.asmp.org*

AOP (Association of Photographers): UK professional body for advertising, editorial, and fashion photographers. Runs competitions and awards, promotes the work of students, and advises on careers and job vacancies. *www.the-aop.org*

BAPLA (British Association of Picture Libraries and Agencies): UK trade association for picture libraries, the largest of its kind in the world, with more than 400 member companies. *www.bapla.org.uk*

British Institute of Professional Photographers (BIPP): maintains a portal and search engine with access to thousands of photographers worldwide. *www.bipp.com*

British Press Photographers' Association (BPPA): organization for professional photojournalists. *www.britishpressphoto.org*

Bureau of Freelance Photographers: UK resource for freelance photographers. Publishes books, market newsletters, and annual market handbook. Also runs courses. *www.thebfp.com*

International Freelance Photographers Organization: US-based organization for freelancers. *www.aipress.com*

The Master Photographers Association: UK-based organization for full-time photographers. Members' forum, regional news and events, and suppliers' directory. *www.thempa.com*

National Press Photographers Association: professional organization for US photojournalists. *www.nppa.org*

Photographic Society of America: interactive organization for photographers of all levels. Monthly magazine, competitions, study groups, and tutorials. *www.psa-photo.org*

Professional Photographers of America: the world's largest nonprofit association for professional photographers, with more than 14,000 members in 64 countries. Organizes conferences and conventions; member benefits include discounts on equipment hire, insurance, and other services. *www.ppa.com*

Royal Photographic Society (RPS): has been at the forefront of photography for 150 years. Members' forum, workshops, prestigious annual competition, and qualifications recognized worldwide. *www.rps.org*

Society of Wedding and Portrait Photographers/British Professional Photographers Associates: twin organizations that offer a variety of member benefits: workshops, seminars, roadshows, and publications, as well as equipment reviews and a directory of photographers. *www.swpp.co.uk*

Wedding and Portrait Photographers International: US resource site for wedding and portrait photographers. *www.wppinow.com/eventphoto*

Other resources

www.business.com/directory/media_and_entertainment/ photography/associations
Links to photographers' associations worldwide.

www.photo.net
General resource site for photographers.

www.photosights.com
Online stock library site.

www.profotos.com
Site for professionals, with online members' galleries; and many useful links to other organizations.

www.wedding-directories.com
Listings for UK wedding photographers.

Most states and major cities in the US have an area-specific online directory for portrait and wedding photographers. There are many online galleries for fine art photography, too numerous to list individually. Search by keyword for your specific area of interest. There are also camera clubs in most towns and cities, which can usually be found via an online search or by looking for notices at local libraries, community centers, or photographic retail outlets. Most equipment manufacturers operate users' Web sites, which contain member portfolios, product reviews, and tips on getting the most from your equipment. Larger towns usually have at least one equipment hire supplier. Check your local business directory for services, or enquire at your regular photographic retailer.

Index

Acknowledgments

Many thanks are due to Kylie Johnston and April Sankey at RotoVision for commissioning this book, to Karen Hood of Balley Design Associates for the page design, and to Luke Herriott and Gary French at RotoVision for overseeing the design process. Special thanks go to Mandy Greenfield, whose meticulous editing and thoughtful suggestions helped to keep the project on track. Most of all, however, I would like to thank all the photographers who so generously agreed to contribute their time, expertise, and images.